This Their Dreaming

Legends of the Panels of Aboriginal Art in the Yirrkala Church

by ANN E. WELLS

Photography by E. James Wells

University of Queensland Press

This Their Dreaming

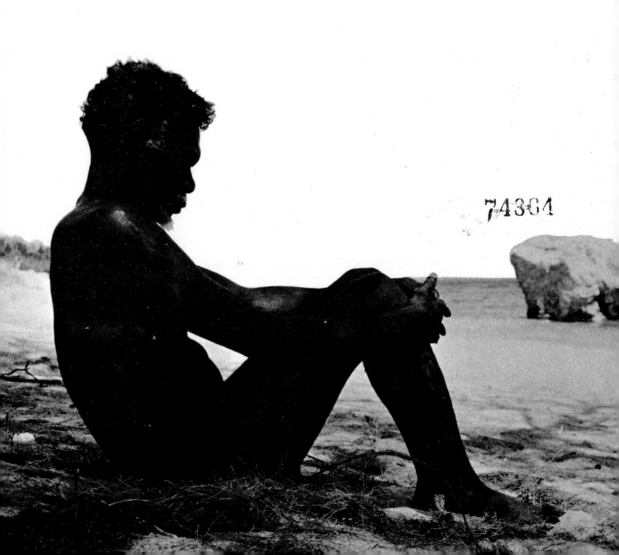

National Library of Australia card number and ISBN 0 7022 0692 X

Distributed by International Scholarly Book Services, Inc. *Great Britain – Europe – North America*

Set in Times Roman 11/13 and printed on 120 lbs Glazed Woodfree. Printed and bound by Dai Nippon Printing Co. (International) Ltd., Hong Kong

Designed by Cyrelle

to JAWA *(Yindi Jolpah of Arnhem Land)*

CONTENTS

ILLUSTRATIONS

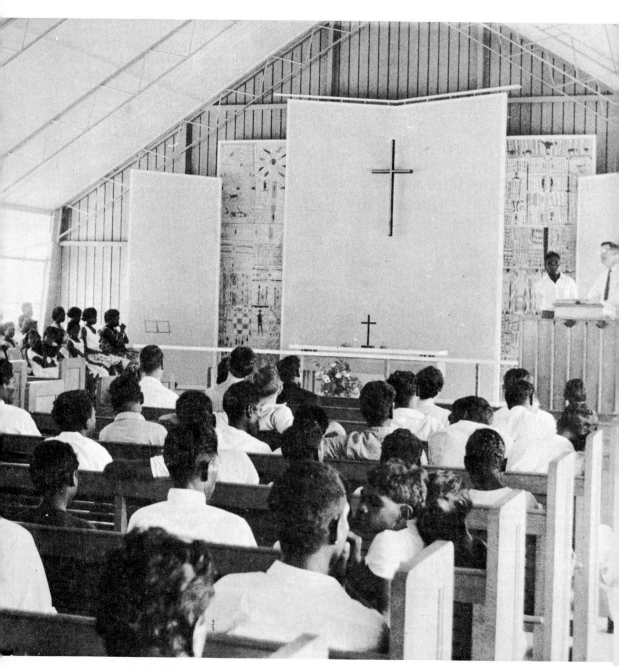

Panels in Place in Yirrkala Church

PREFACE

Some time before the end of the year 1962, two great panels of Aboriginal art were begun. They were painted for part of a screen placed behind the Communion table in the Yirrkala church, and represented the two main, creative legends governing the lives, the behaviour and the ritual of the Aborigines belonging to a wide area of northeast Arnhem Land.

The actual painting of the twelve feet by four feet panels of masonite was a lengthy process, of careful and faithful work and of meticulous attention to correct detail of line and symbol, for the painting on each panel was one continuous legend embodying within its scope outlines of many smaller legends and myths. The pictures were painted in the four earth colours of local stone and clay, prepared and applied as in the traditional way of bark paintings.

The work involved complete harmony of purpose and co-ordination of artistic skill, together with knowledge of the mythology surrounding the figures of their ancestral heroes. The eight artists of each moiety grouping were among the best in the area, being chosen as such by the rest of their people.

Mawalan was the acknowledged leader and custodian of ritual legends and songs for the Dua moiety, the Dua legend being that of the arrival, the journeys, the adventures and the creative activities of Djankawu and his two women-folk.

Birrikidji held a similar position of honour among the Yiritja people, whose creative legends were based on and woven through that of Banaitja. Banaitja, whose mythology has been jealously guarded by the Yiritja "men of high degree" (to use Professor Elkin's significant phrase), was an ancestral figure of ritual power, and leader or relation of three other spirit men. The shadowy figure of a spirit woman moves through a part of this great legend and is held in high regard by men of the inner circle of elders. She has several names, but the one by which she is best known is Nyapililnu.

In the interpretation of the panels Mawalan and Birrikidji were each aided by two men. Birrikidji shared his honours with Mangarawui and Naritjin, both men in this case being ritual leaders in their own language groups and of equal status as artists. Naritjin, being the most fluent in the English tongue, was spokesman for the Yiritja men.

Mawalan's brother, Mataman, is co-authority in regard to the Djankawu legend, while Mawalan's son, Wondjuk, worked with both and translated for them. In his own right Wondjuk is an artist of high merit.

The panels were completed and in place by March 1963, but the photographs used with this work were taken in February, before the supporting centre and wings of the screen were erected. These, while giving an impression of recessed depth to the panels, make photography of the completed paintings difficult.

On 2 October 1963 the church building was used by the Yirrkala Youth Choir to entertain visiting members of parliament, at the close of the historic Parliamentary Select Committee's hearing in regard to the feelings of the Yirrkala people about their land rights. This hearing was held in answer to the "bark petitions" sent by the elders of Yirrkala. The distinguished visitors, parliamentarians, secretaries, officials and pressmen, were visibly moved by the haunting quality of the young Aboriginal voices and the range of music offered in both English and the local languages.

The artists of both moieties requested that no one question what they were painting until the panels were complete. This request the staff honoured, leaving the men to work quietly day by day, within the shade of the church roof as they wished.

Gathering the stories associated with the two great legends took many quiet sessions with the informants of each group. Sometimes the meetings took place in the church building, before the panel under discussion. Sometimes those most informative interviews were held within the shelter of the Mission house on the cliff, where sea breezes were always blowing' and where morning or afternoon cups of tea could add refreshment. There photographs and sketches of the panels were used for reference. The stories were checked and rechecked, previous notes often being read and commented upon, corrections made, and obscure word pictures clarified. All the informants were keenly interested in the work and courteously insistent that no errors should be set in the permanent record.

The Yiritja word was given mainly by Birrikidji and Mangarawui, with Naritjin interpreting where necessary. The Dua stories were given by Mawalan and his son Wondjuk, for the other chief authority, Mataman, spent much of that period in the Darwin hospital. At times the other artists would be present, to give their own particular slant on the main legends or to add their expert skill and knowledge of their own tribal country to the discussion.

Though there appear to be unexplained gaps in the mythology surrounding the two great legends concerning the doings of the ancestral

heroes, Djankawu and Banaitja, their word in recitation and song reveals something of the reaching out of man's mind and spirit into the unknown, the attempt to explain life and creation through symbol and ritual. These legends helped in the formation of the pattern by which the Australian Aboriginal of that area ordered his daily existence on earth so that he might worthily re-enter the world of the spirits, when death brought him full circle through this phase of his Eternal Dreaming.

Both Dua and Yiritja men of authority declare that in the Beginning the two great heroes, Djankawu and Banaitja, were "rambangi" (equal or level), and could have belonged to the same family grouping in the spirit world from whence they came. The paths on earth that they trod ran somewhat parallel, yet diverged so that each fulfilled a special part of the creation story in that "Time before the Morning", as the days of creation are called. The doings of those heroic ones are now remembered by the descendants of the men to whom they are said to have given and taught so much; remembered by ceremonial dancing where their deeds are re-enacted; in the song cycles sung around flickering camp fires to the music of yiraki (drone-pipe) and clap-stick; in their totemic symbols; and in the sacred paintings on bark and cave wall and the human body.

Where shadowy traces of race memory end and invention or inspiration begins is not discernible now, after so many generations and so many centuries of time since the first men danced the rituals of Djankawu and of Banaitja. However, the figures of sea and air and land creatures named in the legends are based on reality. The ngainmara, represented now by a shallow cone-shaped mat, is a case in point. Mawalan was emphatic that the original ngainmara was "like a whale", and that he himself had seen the great sea creature several times. For better definition he sketched the ngainmara as seen from several angles, supplying as he did so quite a detailed description of its eating habits and its love of resting on the top of the waves in a sunny sea. These were sent down to Dr. Endean of the University of Queensland, who suggested that the creature might very well be a sunfish. When shown the picture of a sunfish in a book of Australian marine life, Mawalan nodded his complete agreement. That the ngainmara was what we called a sunfish was final and Wondjuk was equally emphatic on the matter.

Here I would like to record my gratitude to Dr. Endean for his courtesy and assistance.

ARTISTS OF THE DUA MOIETY

MAWALAN,
MATAMAN, } (Riratjingu Language, Yirrkala Country)
WONDJUK

GUNGUYAMA (Jambapuingu Language, Dalpiyalpi Country)

LARRTJINA (Ngaimil Language, Darapangan Country)

MUTITPUI (Djapu Language, Damalmirri Country)

MITINARI (Galpu Language, Mamarin Country)

MUNAPARRIWI (Marakulu Language, Dhurili Country)

ARTISTS OF THE YIRITJA MOIETY

BIRRIKIDJI,
GAWARIN } (Duluwangu Language, Narrkala Country)

YANGARIN (Duluwangu Language, Nyangbu Country)

MANGARAWUI,
JARRKUJARRKU } (Gumaitj Language, Dulbungu-Rrayun Country)

WATJUN (Gumaitj Language, Yarrawirri Country)

NARITJIN,
NANYIN } (Manggalili Language, Birrlung Country)

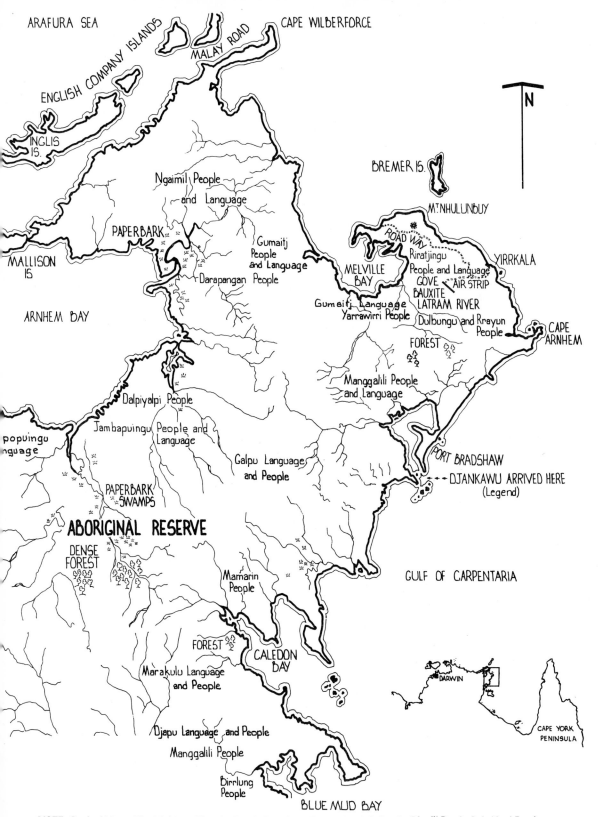

ARAFURA SEA

CAPE WILBERFORCE

ENGLISH COMPANY ISLANDS

MALAY ROAD

INGLIS IS.

BREMER IS.

Mt NHULUNBUY

MALLISON IS.

Ngaimil People and Language

PAPERBARK

ROAD WAY

MELVILLE BAY

Riratjingu People and Language

YIRRKALA

Gumaitj People and Language

GOVE AIR STRIP

BAUXITE

ARNHEM BAY

Darapangan People

LATRAM RIVER

Gumaitj Language Yarrawirri People

Dulbungu and Rrayun People

CAPE ARNHEM

FOREST

Manggalili People and Language

...poyuingu ...nguage

Dalpiyalpi People

Jambapuingu People and Language

Galpu Language and People

PORT BRADSHAW

DJANKAWU ARRIVED HERE (Legend)

PAPERBARK SWAMPS

ABORIGINAL RESERVE

DENSE FOREST

GULF OF CARPENTARIA

Mamarin People

FOREST

CALEDON BAY

DARWIN

Marakulu Language and People

CAPE YORK PENINSULA

Djapu Language and People

Manggalili People

Birrlung People

BLUE MUD BAY

NOTE: *South of Map to Blue Mud Bay:* Nyangbu People, Damalmirri People, Narrkala People, Dhurili People, Lukubirrni People, Duluwangu People and Language.

Map of Northeast Arnhem Land Showing Country of People Mentioned in Text

Dua Panel
Legend of the Djankawu Journeys

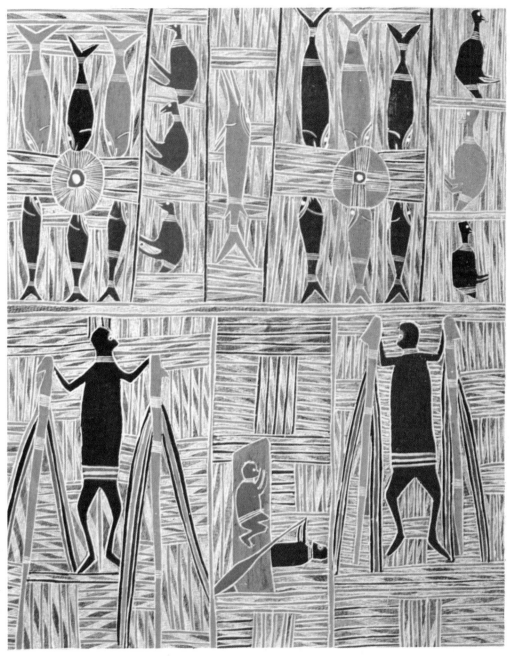

Part of Dua Panel

Dua Moiety

In northeast Arnhem Land the moiety division cleaves through all creation, animate and inanimate. One is born into the father's moiety, inheriting the moiety name, and with it not only the area of land belonging to the family grouping, but one's part in the ceremonial ownership of the ancestral mythology associated with that moiety title.

A man marries a woman of a subsection of the opposite moiety, and the children of that pairing are entitled to use the folklore and sacred ceremonial of their mother's people by special permission — but their father's ritual pattern is theirs by right. It is revealed bit by bit over the years at initiation times, and only those elders who have been able to participate fully in the great ceremonies over many years may know all the mythology and can interpret its meaning.

The Dua people have been generous to strangers who have shown interest in their religious mythology, and, in consequence, the legendary figures of Djankawu and his two women have become comparatively well-known, through the writings of authoritative anthropologists. However, the Dua panel depicting the travels of the Djankawu family shows in some detail their adventures and the places they visited, and the following text is an explanation of each section of the painted panel.

The songs quoted in the following pages of the Dua section were recited mainly by Mawalan, and were carefully interpreted by his son, Wondjuk. With a literal translation of this language it is difficult to achieve a sense of the rhythm and continuity of their songs, as one word may require a full sentence to explain its context and a whole concept be embodied in one short phrase. So they have been rendered in a more or less readable form of English.

Recently word has come that Mawalan has been recalled to the spirit world of his people. Here it is appropriate to pay tribute to a truly gentle man and a great artist, for Mawalan was both. His knowledge of song and legend and bushlore, together with the "inside" or deeper meaning of each, was profound. His kindly willingness to share that knowledge with people of another race was proof of his warm generosity. He was truly a "yindi jolpah", a great old man, and one of the wise elders of his countrymen. He had the insight both of a poet and of one who was possessed by a deep love of his people and of his ancestral earth—the place of his sacred Dreaming.

8 Three Legends *Mutitpui*	**10** The Sunrise *Mitinari*
7 Travelling Through Artist's Country *Larrtjina*	**9** Swamp Country *Munaparriwi*
	5 First Camp *Mataman*
6 New Country *Gunguyama*	**4** End of Sea Journey *Wondjuk*
3 Sea Creatures Seen on Journey *Mawalan*	
2 Beginning the Journey *Mawalan*	**1** Djankawu Leaving Baralku *Wondjuk*

4 ft. 0 in.

4 ft. 0 in.

4 ft. 2 in.

1 ft. 6 in.

2 ft. 4 in.

4 ft. 0 in.

2 ft. 3 in.

2 ft. 0 in.

2 ft. 3 in.

1 ft. 6 in.

12 ft. 0 in.

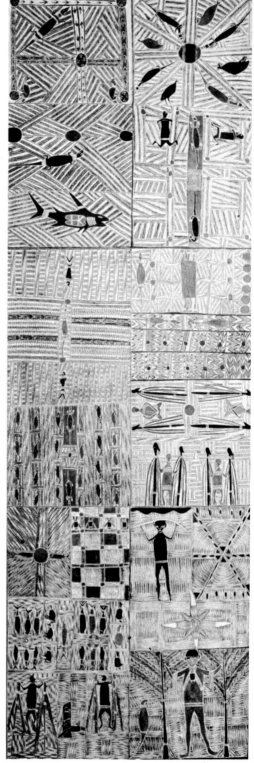

Dua Panel

Travels
of the Djankawu

The Dua panel stands to the left of the Cross as one faces the front screen in the Yirrkala church. The eight artists who painted it worked under the direction of Mawalan, each one depicting his own version as he thought best, and painting in his particular area of country·over which the ancestral spirits had travelled.

This panel is read by beginning with Wondjuk's picture of Djankawu in the bottom right hand corner. The pattern from there follows in an uneven zig-zag through Mawalan's section, returning to Wondjuk and then on to Mataman. After Mataman's section each other artist fits in where the size of his section and placement in the story seemed best to those directing the operation.

Djankawu Leaving Baralku 1

Djankawu here is shown standing on a cliff on the island of Baralku. This mythical island lies somewhere near the rising of the sun and is the place where spirits of the newly dead go on leaving their familiar earth. Baralku is peopled by spirits, who wait to welcome the new soul and to see that he or she is ritually correct as to totemic body painting and mourning ritual performed by those left behind on earth. One of the spirits, the beautiful Morning Star, Bainambirr, is often to be seen just before sunrise, shining in the east to show the departing spirit the way to its destination. The reason why the Morning Star never lifts far up into the night sky is that she is held to Baralku by her friends who do not wish to lose her; for she is fastened in a net whose draw-string reaches down to the spirit island.

For a long time Djankawu, the wise one, had been wondering about a cloud that hung low, and practically stationary, above the distant horizon, as he stood gazing out to sea. That low cloud stirred his imagination and

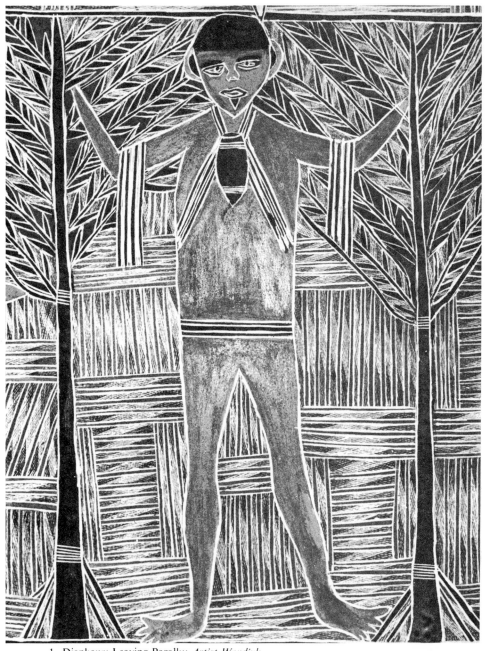

1. Djankawu Leaving Baralku *Artist Wondjuk*

seemed to be calling to him of a strange land beyond the waters. The idea of an unseen country made Djankawu restless and at last he decided to visit that place in the company of his two women, the sisters Bitjiwurrurru and Madalaig. They would take with them spirits of living things with which to people that land if it should be empty of life and eventually their own children could walk there as men and women.

In the picture he has already decided to go across the sea and so he is planting two sacred she-oaks, Djuwata, on the cliff, as a reminder that he had gone from Baralku and had left something behind him to remember and to call him home again when his adventures were over. Watching him is his constant companion, the goanna Djunda, who stays beside Djankawu as he places the calling or whistling trees into position on the cliff. The singing of the wind in the she-oaks by the shore is always a reminder of those sacred trees on Baralku to those who have been initiated into the story of Djankawu.

Here Djankawu is dressed and decorated for a ceremonial farewell dance. He has strings of parrot feathers hanging from armbands above his elbows, the band for his belt was made of human hair belonging to the sisters, and the ritual bag hanging from his neck is called Gundamurra. The Gundamurra contains the spirits of bush and water creatures with which to stock the new land to which he is going. The grid pattern of hatching behind Djankawu in this picture is that of his own country, the sandy hills and green valleys and the prolific seashore. Djunda, the goanna, is resting on a patch of loose sand, a favourite place for the sun-loving creature.

As Djankawu stood gazing across the sea towards the west, that long ago day in the Time Before the Morning, his sister Bitjiwurrurru joined him and asked him why he was planting the trees.

"Look, Sister", he said. "That cloud is always rising from a far-off land. I think it a good thing to get our canoe and to paddle towards that place."

Madalaig, the younger sister, heard him and answered for both women. "All right Brother. We listen for your word because you are the leader."

When the trees were planted the three spirit people made a ceremony, beating with the bilma, the music sticks, and with the mawalan, the sacred digging sticks belonging to the women, while they danced and sang to make ready for the long sea journey.

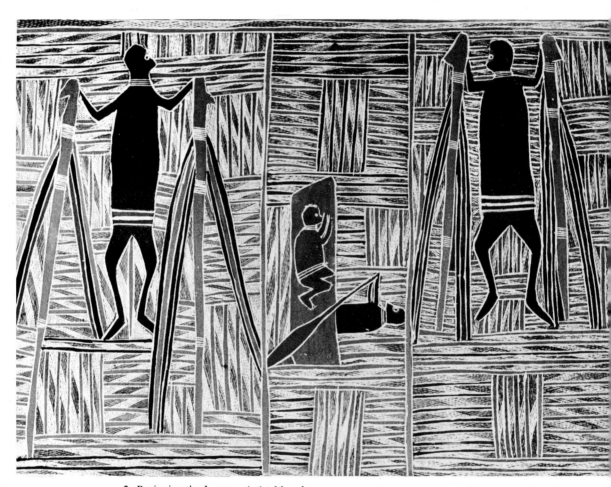

2. Beginning the Journey *Artist Mawalan*

2 Beginning the Journey

After the ceremony Djankawu and his two women moved down towards the seashore and their canoe. The first figure in Mawalan's section shows Djankawu, standing on the shore, holding his sisters' digging sticks.

At the beach Djankawu stood first gazing towards the sea, then turned

back to see Djunda, the big goanna, looking at him from his perch on the sandhill. He also saw his tracks leading down to the sea and he said in a song, "This is my track. I leave the island because I saw the rising cloud on the mainland." And he felt sorry to be leaving Baralku, his home place.

As Djankawu and the two women pulled away from the beach in their canoe, Djankawu sang:

> Ngaiya gananandhangu Baralku
> (We are leaving Baralku)
>
> Bilinangalan nunha wulma
> (Because we saw that rising cloud)
>
> Bili ngaya ngarru gananan Bipinyinna
> (Because I, myself, am leaving Bipinyinna (inside name for Baralku))
>
> Ngali galiyana nandiwangan
> (We are paddling vigorously (moving our hips))
>
> Yappa, ngupana ngarru walinyinna.
> (Sisters, we are reaching towards the mainland.)

In the middle little picture, of Djankawu paddling the canoe, the figure of a woman lying down is really representing the two sisters. A little way out from shore the waves grew rough and the two women became frightened, so they lay down in the bottom of the canoe while Djankawu, the strong one, continued paddling alone, at least for a while until their fright wore off.

At first the things the three saw on their long sea voyage were moving back before the wind and the tidal currents towards Baralku. The sisters were sorry to see the things tossing on the waves and going back towards the home they had left. One of the first things they saw moving with the water was some drifting wood. The sisters asked Djankawu what it was and he answered gently, "Those, sister, are pieces of timber." So Bitjiwur-rurru asked was it good timber, and Djankawu answered with a song.

> That is light wood, good wood,
> drifting back to Baralku,
> for it is belonging to that place.
> Strange wood drifting on the sea
> and moving up and down with the motion of the waves.
> See, a whole tree-trunk drifting
> with waves splashing against it.

> See the spikes of branches of Gayndjara (name of tree)
> showing above the splashing spray.
> In the wet season it was washed out
> by the fresh water running;
> now it is drifting back towards the beach,
> our home beach that we can only see now from the wave tops,
> for it is a long way off.

Then one of the sisters asked, "Brother, what is that bird resting on the drifting timber?" Djankawu answered with another song, singing to the rhythm of his paddle.

> That bird is Guthaka (the sooty oyster catcher)
> calling out from the floating timber;
> calling, calling, then flying up towards a long, smooth cloud,
> flying with short wing beats;
> crying up and up through its red beak.
> See, it is flying up and going round more slowly;
> now coming back to rest on the log;
> now skimming the water in the middle of the sea,
> the blue sea, the deep sea, the sea far from land;
> now it is coming to circle this canoe.
> Listen to the crying of Burrungba (the inside, singing name of the bird).

3 Sea Creatures Seen on Journey

In the panel section just above Djankawu and the sisters, Mawalan has painted a variety of fish and waterfowl, together with a porpoise, and two sunfish (usually referred to as ngainmara). The travellers saw many kinds of fish and sea birds, as well as turtles, dugong, porpoises, sharks, and whales. All these living things were given names as they were sighted by Djankawu and the sisters. When they saw porpoises gambolling around them in the deep water, splashing gaily on top of the rough waves, their bodies dark as night against the sunlit water, Djankawu told the sisters a story about them.

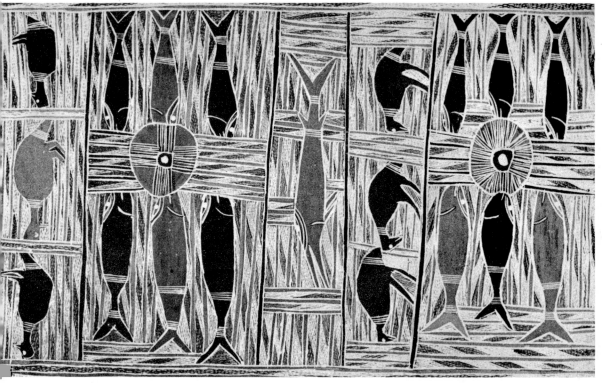

3. Sea Creatures Seen on Journey *Artist Mawalan*

Porpoises, he said, are often really spirit people looking after the fishermen and travellers who go out into the deep sea in their tiny canoes. The porpoises shepherd the canoes away from heavy rain and storms, talking through their long noses as they lift above the waves and blow. When a person is very sick in a camp by the sea the porpoises come in close for a day or so before he or she dies, bringing a message of comfort that the spirit people will guide that one safely into the next world at the time of death.

When the travellers were far away from any land, about half way through their adventurous voyage — for here the waves were so big that they made green hills and blue-veined valleys where white spume made running

patterns for the tiny canoe to move across — they saw a huge, round, shadowy shape lifting in the slope of an approaching wave, a sunfish large as a young whale.

The older sister wailed, "What is this strange thing like a living mat that is coming towards us to block our way?"

Djankawu answered, "That, sister, is a Ngainmara."

Bitjiwurrurru asked him then, "Is that thing good for us?"

Her brother spoke with a quiet voice, "If we do not bother that thing it will not harm us. See as it comes closer how it lies lazily like a red-brown mat on top of the water. Look at its large mouth where the sea water is bubbling in and out all the time while it is feeding on tiny things that float in the sea. If we alarm that ngainmara it might go down quickly in the water and make a whirlpool as it goes and pull down our canoe. That is the only way it might harm us. So we will pass by it quietly and leave it feeding in peace."

So the two sisters sat still in the tossing canoe, watching the great sea creature with eyes that were half full of fear and half of wonder.

"Surely it is like a great mat," they said to one another softly, and the older one said she would weave a mat like it out of pandanus, "as we weave our hunting bags, only for the ngainmara mat we will make a fringe all round like the fins or ripples that are round the edge of that great fish's body. Then, when we see our sacred Ngainmara we will remember this giant sunfish, for it is a wonder to see out here in the deep water."

And so the ngainmara is still made to this day, a mat shaped like a shallow cone, used as a cover for the very old or the very young in the camp, or as a special part in one of the initiation ceremonies.

4 End of Sea Journey

Thunderman

Above Wondjuk's first painting, of Djankawu making ready for his long journey over the sea, are three separate sections. In chronological order the story of the Thunderman comes really before that of the Morning Star, for he appeared to the travellers in the late afternoon of their first day

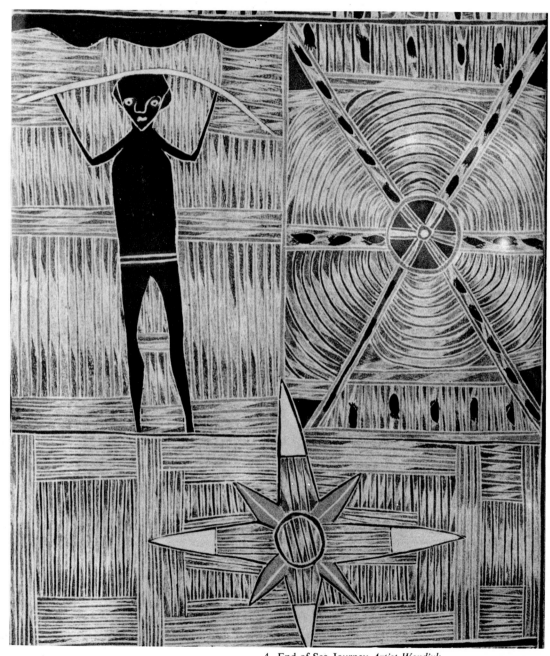

4. End of Sea Journey *Artist Wondjuk*

while they saw the Star early the following morning. So here is the story of the Thunderman.

The cloud bank, towards which they had steadily paddled since leaving the shores of Baralku, had risen in the sky, until by late afternoon it began to loom over them in a storm formation. Tall peaks of cumulus rose dark against the westering sun, their summits edged with a dazzling veil of cirrus, while blue-grey curtains of rain were beginning to fall at their feet.

Suddenly, near the storm centre, swirls of cloud blew aside to reveal the figure of an immensely tall man. He stood as a hunter stands, hands upraised to hold a shining bow of silver light like a long spear ready for throwing. (A hunter, when demonstrating his spear-throwing prowess, either in friendly competition with others or in a ceremony, may sometimes stand with his spear above his head and held in both hands while gauging the direction and distance of his throw. His spear-thrower is held in his right hand against the butt of the spear and when about to throw the hunter drops his left hand free while the spear is swung in a smooth arc into throwing position against the right shoulder. The classic movement in such spear throwing is as beautifully balanced and co-ordinated as the discipline of ballet.) Around the man's figure the lightning flickered, revealing now a lifted arm, now a sinewy leg, now a proud and austere face, and finally, a line of water drawn like a charcoal stroke from penis to the wind-wracked sea below. For several slow minutes the three people in the canoe watched the line as it sprang in a clean curve from cloud to sea, then it wavered, broke, and was gone as it became absorbed into the following rain.

The tall man in the clouds looked towards Djankawu and the sisters and a brief, shadowy smile lightened his harsh features, just as folds of cloud mist surrounded and obscured him from their view. The rain storm passed the travellers some miles to the west, and all they received from its riotous passing was a gust of wind and a quick swell in the waves.

The sisters, when they saw the Thunderman, were very scared and asked their brother fearfully who it was.

He replied briefly, for he was watching the movement of the storm clouds.

"That is Jambawal, the Thunderman."

The sisters then asked, "Is he going to hurt us?"

Djankawu picked up the bilma, the music-sticks, and passed the paddle

to one of the women. Then he sang to them the story of the Thunderman.

"It is a good thing to see that Thunderman," he said. "For Jambawal is the spirit belonging to a special country. Now we have seen him we know that the land to which we are going is there beyond the cloud bank, and that it is a good land with plenty of bush food and yams. Jambawal is the spirit for bringing rain to that country, and he is also the one who plants the yams in the right season. Many are the songs I can sing of Jambawal, the Thunderman.

"It is Jambawal who makes the waterspout, that line of water we have seen between the clouds and the sea.

"It is Jambawal who holds the Larrpan, the mighty spear that flies like a shooting star across the sky in the night time, whose passing makes the thunder and whose hitting of the great rock cod calls up the rain.

"It is Jambawal who throws the Larrpan over a clear night sky to tell those who mourn that one newly died is travelling safely to Baralku, and knowing that thing the mourners are satisfied. Thus it is spoken."·

By the time that Djankawu had ended his singing of the story of the Thunderman, the sisters were once again relaxed and unafraid and the storm was already receding into the southern corner of the evening sky.

The three people travelled on, feeling refreshed in the coolness left behind by the storm wind and the going down of the fiery sun. Behind them in the east the almost full moon had already risen. It floated, pale gold and fragile in the twilight, but when the night had fully come it hung like a warm and solidly ripe fruit against the starry sky, sparks of its reflected light dancing on the lifting waves, holding at bay some of the eerie mystery of night-time on the open sea.

Soon after midnight, when the moon had swung above the little canoe until it shone ahead of them towards the west, they all saw something that made them gasp. A large wave had lifted them lazily so that for a moment they were poised on its crest and could see a long way over the sea. Low down, a thin dark line between the sea and the edge of the sky met their tired eyes. It was land. Far off still and only to be seen in snatches, but it was land, waiting for them. Their travel weariness left them and they paddled with new life, singing as they drove their tiny canoe faster over the water. By the time the moon slid down in the west they were able to see a black, quiet line that did not move, cutting across the moon's face like the thin blade of a flint knife.

Morning Star

But with the going of the moon and its comforting light the three people began to feel how very far they still were from shore, and to wonder whether they would find it or paddle in circles instead, under the impersonal light of the stars. The fears of the two women returned and they began to cry, until one saw something that made her exclaim, "Look brother, look behind you. What is that new light shining like a pearl on the edge of the water?"

Djankawu looked and felt his heart grow joyful again.

"That is one of our friends from Baralku", he said. "That is Bainambirr, the Morning Star."

"What does it mean? What word does she bring?" the sisters wanted to know.

Then Djankawu told them the story of the Morning Star. He told them how Bainambirr had wanted to guide them with her light, after the light of the moon had gone. He told them how she had persuaded her friends to tie her in a net and hold her to Baralku with a string, so that she would never leave that beloved place. And he told them that Bainambirr brought the travellers a message that their friends on Baralku were remembering them and would wait for their safe return when their work on the mainland was over.

This so cheered them all that the little canoe flew forward over the quietening waves, until, by the time that the sun was beginning to turn the sky above them a delicate grey, brushed with thin lines of faint pink cloud, they found they were quite close to land.

Ahead of them, from the north to the south, stretched the dark green line of mangroves, still far away but slowly coming nearer and taking shape into headlands and bays and low, grey-blue inland hills. Nearer to the canoe were several rocky islands.

Seeing the land, solid and reassuring ahead of them, all three people felt very glad, but, oddly enough, it made the two women realize how very weary they were.

"Where are we going to rest, for we have been paddling the whole night long, brother", they said.

Djankawu did not answer them immediately, for they were approaching the first of the rocky islets. He turned the canoe so that it moved into the

shelter of the landward side of the islet, running up until it touched the stony fringe of beach there. Then he answered the women.

"This place we will call Garayngaraynbuy, because this is the first place where you will put your feet on land since we left our home country to come over the sea. We will rest here for a few minutes but we cannot stay, for these outer islands are barren and are exposed to the wild spray when the wind is blowing."

So they rested for a few minutes and then moved on, passing the next islet at a safe distance, for it was a jagged rock, surrounded by waves that leapt and thundered and broke in wild spray. This place Djankawu named Bawali.

From the third island, as the canoe approached, flew flocks of small green parrots with bright red breasts, trilling and crying to one another as they whirled round in the clear morning air.

"What are those birds, brother?" asked one of the sisters, who were both watching the movements of the birds with delight.

"They are called Lindiridj", Djankawu replied. "See, there they are flying towards the mainland in their flocks, flying fast and calling as they go. They will feed on honey from the flowering trees all day, and at night will fly back to this rock. See the shelters that the birds have found in the stony cliffs? This island is a safe place where they live, and in those holes they make their nests. When it is the nesting season you can hear a murmur of birds' voices always around this place. It is called Wulpinbuy. The feathers from the golden-red breasts of the birds, the Lindiridj, are for the sacred bags and for the marayin (sacred) strings we make for the ceremonial dancing."

Then the sisters looked at the rock and saw that it was honeycombed with small clefts and cave openings.

The next islet was low and covered with mangroves. As they paddled past the green walls they heard a night bird calling to its mate as the two settled down in the dense trees for their daily rest. This island Djankawu called Gakuba.

At last, just as the sun was rising warm and rosy above the edge of the sea behind them, the tired travellers came to a place that looked at first like an island, but proved to be a peninsula joined to the mainland by a narrow neck of reef. This place Djankawu named Bilipinya.

"Here on this place, this Bilipinya, we will make our first camp", he

said to the women. "Here our feet will first tread on the new land we have come so far to find. This will be a very special place. Come, sisters. Help me to pull the canoe on to the beach and then we will find some fresh water and make our first meal."

The two sisters followed Djankawu gladly, helping him to make the canoe fast high on the beach.

Waterhole

After that the spirit man and the two women looked about them for fresh water, but they could find none for it was mostly bare rock. Finally they climbed to the summit of the headland, an expanse of solid rock lying naked in the early morning sunshine.

There Djankawu took one of the women's digging sticks and smote the rock surface as if to dig a hole. Beneath the mawalan, the digging stick, the rock opened into a deep, oval-shaped depression. The basin filled with fresh, sweet water which rushed in so fast that it made a whirlpool, glittering in the sunlight.

The picture of this rock pool is painted on the panel, just above the Morning Star. Its crystal clear surface is often disturbed by ripples that run and sparkle in circular eddies, when the winds blow across its face. It never runs dry even in the hottest summer days, and is so precious that only the oldest and most senior people are allowed to drink there. This was the word that Djankawu left. Later he dug another hole towards the mainland beach, where the young men and the uninitiated might drink.

The water of Bilipinya is still so clear that when the wind is not blowing trepang may be seen at its bottom, lying like dark contented slugs there on the rocky floor. In the picture, the footsteps of the ancestral sisters are coming and going around the waterhole, and in the centre is the reflection of the sun.

Djankawu and the sisters saw as they climbed up from the beach on Bilipinya the newly risen sun shining warm and life-giving over the sea from which they had just come. They also heard from the rugged little trees on the mainland shore the song of Djikai, a small light-brown bird that sings earliest of all as daylight dawns in the bush. Another name of this tiny bird is Warnba, the honeyeater. Then, after a little while they heard the call of the black cockatoo, Nadthili or Gurruwirrpawirrpa,

and the sound made them feel glad for it made them realize that they were safely ashore after their hazardous journey and that the day had come after their long night.

The three people were so glad about their arrival and the making of the waterhole that they decided to have a ceremony before they actually camped. So the women danced with their hunting bag and their mawalan (digging sticks), a dance that women sometimes dance even now in the country from Milingimbi to Yirrkala, the dance of the digging sticks and the bush-food gathering. Djankawu danced too, as the men do in that dance, beating time with his bilma (clap-sticks), and singing the song of their arrival on the mainland.

First Camp 5

The two sections of panel immediately above Wondjuk's pictures of the waterhole, and the black cloud above the head of the Thunderman, show the family of Djankawu and the sisters at their first camping place on the mainland.

Mataman has depicted the dance of the women on Bilipinya in the lower, or first picture, each sister holding her mawalan. The rock of Bilipinya is symbolized by the cone between the two women.

In the upper picture Bitjiwurrurru represents both sisters, who are seen seated across the waterhole from Djankawu. They have stopped dancing and laid down their digging-sticks, so that they can sing the songs of their travels and adventures as Djankawu leads them with the words and music to the beat of his clap-sticks. This long song cycle is still sung at appropriate ceremonies.

The square type of hatching is typical of the three Riratjingu artists and represents the various aspects of the coastal sandhill country of their area. Here it shows the coastal stretch of rolling sandhills, leading back to the small rugged hills of the distant inland area, part of the country where the three ancestral people landed and made their first camps.

The artists say that this country has great sandhill ridges, one running parallel with another and with the mangrove-bordered coast. Between the hills are shallow valleys that are especially prolific in natural foods,

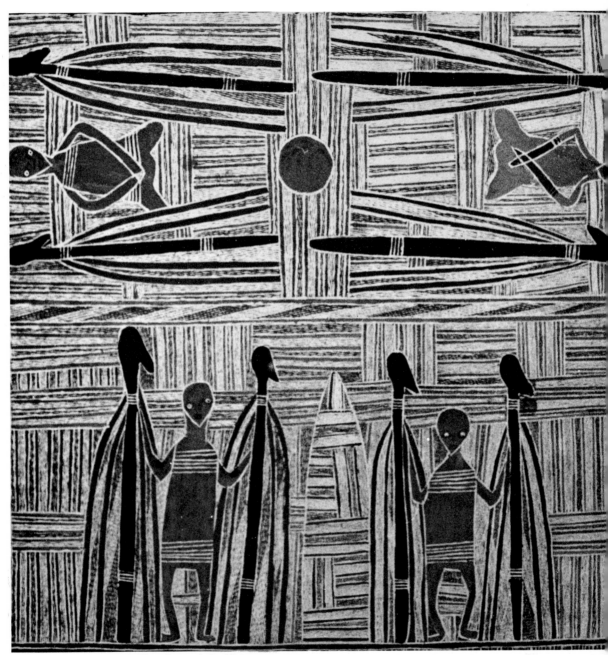

5. First Camp *Artist Mataman*

yams and waterlilies, with an occasional patch of rakai (the local ground-nut) where the salt water seeps from the high tides into the freshwater flats. Here too are stands and groves of paperbark trees. During the dry season these valleys lie like strips of open forest save where the straggling little creeks run from one secretive waterhole to another; but during the wet the whole area is alive with murmurous life, bird life, water life, animal and insect life, while the pythons and other reptiles come into their own. The places are storehouses of food, and filled with the fragrance of flowers and honey and eucalyptus leaves.

One or two of these valleys are so well filled and so secluded, between their ramparts of jungle and stinging tree and prickly vine on the inter-vening ridges, that the old people have claimed them as sanctuary and none but the elderly or the senior may enter there. Here Djankawu and the two sisters are said to have camped a while before they started on their long and exhausting travels through the country.

These hidden valleys are said to be where the two sisters, Bitjiwurrurru and Madalaig, pierced the ground with their sacred digging sticks until the sweet waters ran out freely, bringing with them the forms of animal and bird life at the calling of Djankawu. There he gave them their names and their place in the earth, birds to the air, animals to the bush or the plains, setting them free to wander the land. Here too the first local people, the yulnu, appeared and were taught their own language, the way to paint and to make their sacred totemic patterns and designs, how to perform the great ritual ceremonies and the song cycles they should sing. Here also the people were given instruction in the rules of bush-craft, in the techniques of hunting by sea and by land, the ways of each season of the year, and finally, the kinship laws by which their lives were henceforth to be patterned and held in a closely knit web of behaviour wherein each and every one had a rightful place and rightful obligations.

New Country 6

Above Mawalan's section of the panel and to the left of the Thunderman is the painting by Gunguyama. His land is towards Arnhem Bay.

Gunguyama tells of the travels of Djankawu and the two women across

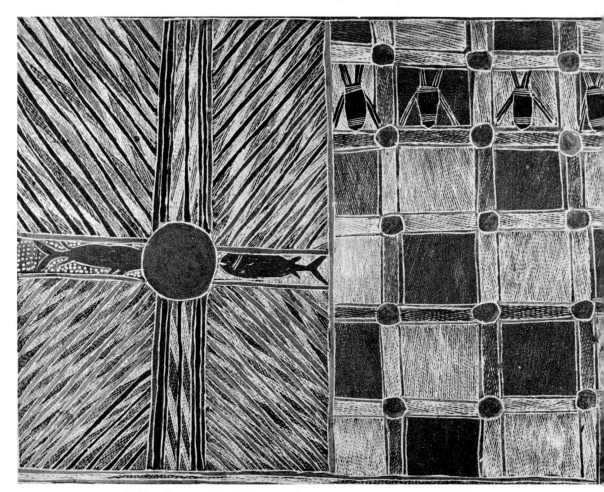

6. New Country *Artist Gunguyama*

his ancestral land, together with some of the arts of living that they taught the yulnu who gathered around them here and there.

As the Djankawu family moved about they continued to dig waterholes for the release of fresh water springs, and they named the various bush creatures that they found.

In Gunguyama's painting the artist has shown the waterholes as round, solid circles. In between the circles are squares, some white and some yellow. The white ones represent salt flats where tidal waters move across at the very high tides, while the yellow squares are freshwater flats, for Gunguyama's country is mostly coastal plain. These places that can look so bare and scorched and lifeless are deceptive, for to those who live in that wide open country there is a hidden and nutritious supply of food, ready for those who know the rules and ways of that type of hunting. Even in the long hot months of the dry season, wallabies find the juicy roots of the seemingly dead grasses and in their turn become food for the hunter; goannas find insects among the melon holes and the scrubby bushes that lean close to the ground; rakai, the ground-nut, may be found where the salt flats and the fresh overlap at the king tides. While, at the sea-bordered edge of the salt pans, great mud crabs hide in the muddy runnels and creeks under the marching mangroves, and barramundi grow large in the green depths of the larger inlets. Where the rakai nuts are ready for harvesting the pied geese can be caught, for they too like rakai.

At the top of this picture are four sacred bags. These are woven of pandanus strands for the initiated men and are usually very well made — so much so that at least one man at Milingimbi can weave a pandanus bag so evenly that it will hold the fluid of the wild honeycomb, without even seepage. Each language group has its own totemic pattern of bag. Some are overlaid with a grid pattern of possum-fur string, some are covered with inwoven feathers from the red-breasted parrots, some are carefully painted in totemic design. Each bag is a symbol of its owner's section of the great myths. For instance, a bag with red feathers surrounding it in a continuous band of several inches in width, represents the sun and her life-giving powers. This is only in evidence when the plain pandanus base is presented so that it bears a fringe of red-gold, like the corona of the sun seen in an eclipse.

These four bags on the panel belong to the people who are entitled by right of direct inheritance or by kinship to hunt over this particular country, and to take part in the ceremonies held there. In order from the left they are — the Riratjingu people, the Garlpu, the Ngaimil, and the Dartuwui.

To the left of the flats is the picture of a fish-trap, one built in swampy country or in coastal streams. This kind is mainly a woven net or pot,

made in open basket fashion of pliant sticks, canes or vines, tied with reeds or pandanus strands, and placed across a running stream so that fish can go in but cannot get out. In the picture one catfish is approaching and another is already partly inside the trap. Spots around the fish are bubbles made by the water running through the reeds.

This picture is a detail of the wet season hunting, for during the monsoon rains the freshwater plains become great swamps, green and moving with bird and fish life. At the shallow reaches of the plains, birds from tiny plovers to the great jabiru move and hunt in countless numbers, dining on the prolific influx of insect life, or on the seeds of grass and waterlily. The hatching here is of freshwater swamps, with streams running in the winding river beds that only bear deep water in the wet season.

7 Travelling Through Artist's Country

Above the sections painted by Gunguyama are four painted by Larrtjina.

Larrtjina's kinship country is in the northeast of Arnhem Bay, taking in several good streams and rivers as well as lagoons and swampy flats. In its interior the area runs back into steep hills and gullies, a watershed from which the lower streams flow through rock gorges and fern-shaded waterfalls, in swift little creeks that unite to form larger streams in the lower flat country towards the Arnhem Bay coast.

Djankawu and his two women travelled extensively through this area and found many good places in which to camp.

One of Larrtjina's totem patterns is of the whistling ducks that live in the swamp country in great numbers. The legend of the whistling ducks is that Djankawu dug the first central waterhole, a lagoon marked on the panel as a black dot. It is the deepest waterhole in the vicinity.

When Djankawu poked in the mawalan and the water came gushing up out of the great hole, he saw goannas and fishes and birds in the water. To each he gave a name and set it in the environment to which it was most suited. The goanna, pictured on Larrtjina's section of the panel, he named Wankawu, and to two species of duck he gave the names Guminyung and Guwi'i'yi. A small fish that is very numerous in the area he named Ngarrkanbal.

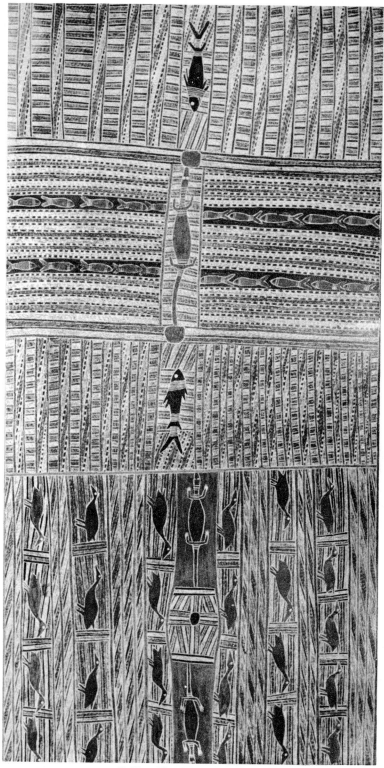

7. Travelling Through Artist's Country *Artist Larrtjina*

The ducks, as they came out of the now muddy hole and saw Djankawu, pushed through the deepening water in a long line, making a great wave that moved ahead of them through the reeds and long grass. The two women, when they saw the line of ducks and the wave that shook the reeds and grass before them, cried out in surprise.

"What are these birds, brother?" they asked. And the man told them that the birds were whistling ducks.

The ducks lifted their dark wings and rose from the water, flying low over the spreading lagoon with heavy wing-beats at first, then rose higher and higher, flying round in growing circles, piping a strange, sweet song as they flew. Then they returned to the water, planing down one after the other in close formation. They then began to look for food in the swampy edges of the lagoon and that is the reason they remained waterfowl. They go backwards and forwards from land to water, camping on the land among the grass in the night-time, and feeding on the water reaches by day. The hatching in this particular square represents the long, reedy grass called dara, which grows long and high in the water.

The two sisters liked the sweet piping of the whistling ducks so much that they made up a song especially about them.

In the centre part of Larrtjina's picture of the ducks in the swamp is the river called Wandawi that grew from the running of the first waterhole that became a lagoon. The two goannas, the wankawu, are floating in the river, for they like the water. The whistling ducks in the picture are moving about the open swampland, eating wakwak, the seeds of the waterlily.

The three Djankawu people moved through this country and stopped for a while there to have a big ceremony, putting down their mawalan and resting near a wide running creek. There is a wonderful supply of food around that place, for the water runs fresh from the hills and goes right down to the saltwater mangroves. On the way are birds and plant foods and freshwater fish, turtles and goannas, while at the saltwater inlets are barramundi and crocodiles. The Djankawu ceremony still used in that area contains songs about birds and fish and water, and the song of the sisters about the whistling ducks. The Ngaimil people who live there are the ones who make the stingray spear for special ceremonies, which spear they exchange with neighbouring groups for other ceremonial gifts.

The four sections of the panel painted by Larrtjina depict his land, from the steep valleys of the hills, down the streams, to the rivers and finally to

the saltwater estuaries and creeks of that part of Arnhem Bay. Each section gives a description of a particular facet of his country, reading from the lowest of this artist's paintings — the first having already been described. The fish, just above the swimming goannas, is moving along a large stream that drains the lagoon and numerous small creeks. The country here is rugged, but with more open forest, with wild banana palms growing along the creek banks.

The section above this one shows where the river begins to meander through flat country and divides into billabongs, wandering channels, and lagoons with marshy swamps at their borders. The spots in this section are bubbles that float to the surface of the apparently still swamp water. These bubbles often indicate by their slow movement the direction in which the water is really flowing, even when it appears quite stationary. Here the channels are alive with small fish. Those seen in the painting are the ngarrkanbal, so named by Djankawu in the time of the early Dreaming. Sometimes here in the deeper rivers, sharks swim upstream into the fresh water in their hunting forays. Here, too, the freshwater crocodile is numerous, as is also the large goanna. In the picture a goanna is seen near two of its holes, one of which it has just left and the other it is entering.

The top section of Larrtjina's painting shows the great coastal plains, where the muddy waters of the wide and curving rivers meet the salt tides. The fish shown is a deepwater one. The hatching here is of grass, so long and lank that it lies over in great swathes after the wet season. Towards the end of the dry the local people burn off this obstructive grass to facilitate their hunting.

Three
Legends 8

The section of the panel painted by Mtitpuui is that above the part done by Larrtjina. The locale of Mutitpui's language group is the country between and around Caledon Bay and Trial Bay.

This should have been painted before that of the previous artist to be in chronological order, as Djankawu and his family travelled this way first after leaving their first series of camps around Port Bradshaw. From here they passed to the southeast of Arnhem Bay, across the narrow neck of

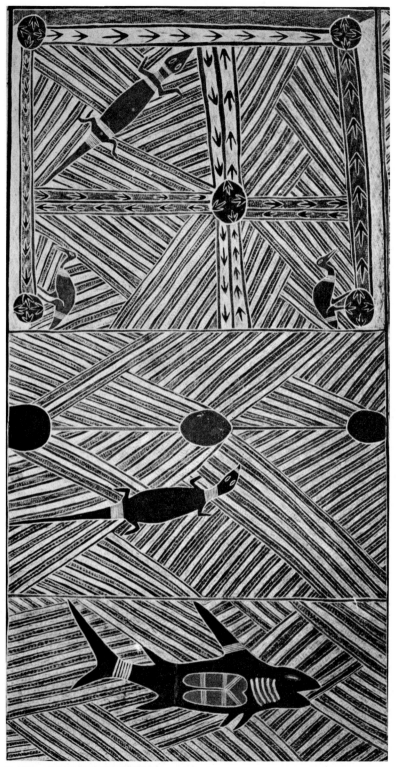

8. Three Legends *Artist Mutitpui*

land that forms the watershed between Arnhem Bay and Caledon Bay. However, as in other sections, the main painting appears to be that of the artist's own country, its fauna and flora, and of some of its more distinctive laws and ceremonies given to the yulnu by the mythical ancestral figures of Djankawu and his women as they passed that way.

The marayin, or totemic symbol, of this area and people is Marna, the shark. The artist has painted a vivid picture of this shark in the lowest part of his section of the panel.

Shark

Here, in the picture, the shark is swimming in a freshwater lagoon, where it was caught by the receding of waters at the end of the wet season. The local river rises rapidly at times, being in flood with monsoon rains that meet with the spectacular inflow of the king tides. Sometimes young sharks are swept upstream on the high tide and are caught in a lagoon when the seawater recedes, thus being retained for almost another year within a landlocked lake. The liver of this particular shark is considered a great delicacy, and only the elderly and the most senior people are allowed to eat it.

The sweeping tail of this shark represents power, while the pointed tail, drawn apart from the shark's body, means the power of seniority and of the words and ritual bequeathed to the people from the ancestral figures.

The teeth from this shark were cunningly fastened into the edges of a bat-shaped piece of hardwood by wax or gum obtained from ironwood. This made a very terrible weapon that inflicted gaping wounds when used in fighting. It, together with a spear headed with the same tooth trim on the blade, was used in ritual battles where one whole language group was involved in a deadly struggle against another group. It should be understood that this type of fighting belongs entirely to the past and is not now in use. Narrtjam is the name for the shark tooth weapons.

The lines of hatching around the shark are ripples and splashes of water surrounding it as it swims on the surface.

Sometimes the people make necklaces out of the backbones of the young sharks. The ceremonial trading item of this area is a stingray spear with string and feathers wrapped round it. These are sometimes traded for things like sacred bags, or for a ceremonial mungul, the spear-thrower.

Phases of the Sun

Above the shark is a section showing three phases of the sun — morning at the right, noon in the centre, evening to the left of the picture.

The morning sun has just risen above the eastern edge of the sea, and for a brief moment rests like a rosy flower on the horizon while delicate red ripples carry her reflection across the quiet waters, with a first breath of her daily warmth arriving on the light breeze. The senior men say that for this fleeting point of time Walu is like the vagina of a young maiden awaiting the love of her husband, while the warm swiftly vanishing rose-flush on the sea is the blood signal of the glad losing of her virginity. The sun here is the female symbol.

The sun-loving goanna Djunda, the friend of Djankawu, is here watching the passing of the sun across the sky as he rests on a sand-bank. The noonday sun spreads her bright heat over the earth, giving light and life to growing things and calling up the rains of the monsoon from the distant ocean.

The evening sun sets in a pageant of colour in this part of the world, often tinting sea and sky and cloud with colours of flame. Sometimes its rays fan out in bands of light from a cloud bank, just before sunset. These are said to be the Wuipa, dust raised by the dancing feet of spirit folk on Baralku, when they are ceremonially celebrating the safe arrival of a soul that has newly departed from a body on earth. This is a word left behind by the Djankawu who travelled over this country and saw the sun rising in the east over the sea, and setting in splendour behind the little hills in the west.

The hatching here represents the sun's rays spreading over the earth and the sea.

Dry Season Waterholes

The picture above that of the three suns is of extensive coastal plains. These plains are part of the country belonging to the artist's people. By the end of the dry season, after any grass that was on them has been burnt off, they lie like great bare areas of earth, dotted here and there by scrubby trees or bushes, and looking dry and hostile to a thirsty traveller who must cross them. The birds are brolgas and the bird footsteps are those of the

brolga, going to and from the hidden waterholes that must be found to sustain life. A hunter in this land who knows the ways of the plains will find the track of the brolgas and follow it until he comes to water. Djunda the goanna is here watching the brolgas, the dangutji as these are called locally, as they walk with their mincing gait along their secret pathways to and from the waterholes.

Swamp Country 9

The three narrow strips painted above the seated Djankawu in the section belonging to Mataman show this artist's own country, Dhurili, which is south of Trial Bay. Here the Djankawu and the sisters Bitjiwur-rurru and Madalaig moved quietly through the swampy country, camping where they could find a dry rise of ground and making freshwater springs there.

The first two sections show bamboo swamps, with long reedy grass and difficult travelling. The dark circles are waterholes set in among the bush and jungle. The wavy type of background lines shows the splashing of the fresh streams as the newly released water rushed from the springs, running through the rank, heavy grass after Djankawu had dug a successful hole. In this country some of the holes they dug with their sacred mawalan were dry and others held only brackish water, but others gave generously of good, sweet water. Some of the sharp lines in the hatching represent a wild palm tree that has very long leaves with knife-like edges — these leaves are called dhurra, and the palms grow in the shallow basins that become billabongs in the wet season.

The thick, straight lines show dry forest land, low ridges that lie here and there among the tangle of swampland, places where men and animals might make camp away from the damp ground of the marshy areas. Djankawu and the two sisters camped on these forest zones during their journey through this part of the country.

Above the patterns of swamp country are two freshwater goannas. These have long necks and were named Djelka by Djankawu. One of them is looking down his hole in the bank of a stream.

Somewhere in this country the two women became very weary of walking in the obstructive grass and jungle growth, finding their digging sticks

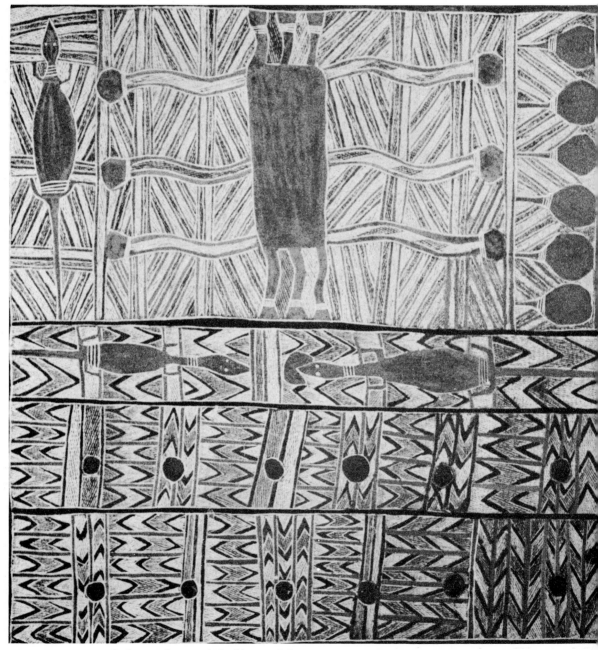

9. Swamp Country *Artist Munaparriwi*

growing heavy and cumbersome. When they came to clearer country beside a large lagoon, they buried their mawalan for the time being so that they could move about that place more easily. By then the older sister was heavy with child and the younger sister was also pregnant. Here beside the lagoon, they made a special tent of leafy branches over a clear place. Until some fifteen years ago, when maternity wards were attached to each mission hospital in that part of Arnhem Land, women who were about to give birth went away into the bush and built themselves just such a leafy tent over a clean swept floor.

This lagoon is the gathering place of innumerable small streams, some running through jungle and some or all well-stocked with dirpu, the waterlily whose seeds the women gather and cook in great quantity. Where there is dirpu there are usually ducks. (The duck egg, by the way, is one of the most sacred totemic symbols of northeast Arnhem Land.) Also, the great water python has his home here and is the totem most recognized as belonging to this locality and people. Their ceremonial trading item is a spear, carved of ironwood and decorated with a special string that represents the python.

The row of stemmed, bulbous circles at the outer edge of this section are waterlily seed-pods, large round pods full of slightly oily seeds. The women gather and cook these seeds, pounding them to form a paste, obviously quite a nutritious food. Ducks almost live on these wakwak, as the seeds of dirpu are called, feeding on them as they burst out of the ripe pods and float about on the surface of the water. To the opposite side of this section can be seen the short-necked land goanna, resting on a grassy bank near the lagoon.

Sunrise 10

Sisters Dancing at Camp

This artist's country runs down into a triangular peninsula in the northwest corner of Caledon Bay. It is partly open country, running back into small ranges, and partly swamp country of paperbarks and great flats.

The lower section of his painting shows the flat swampland where one

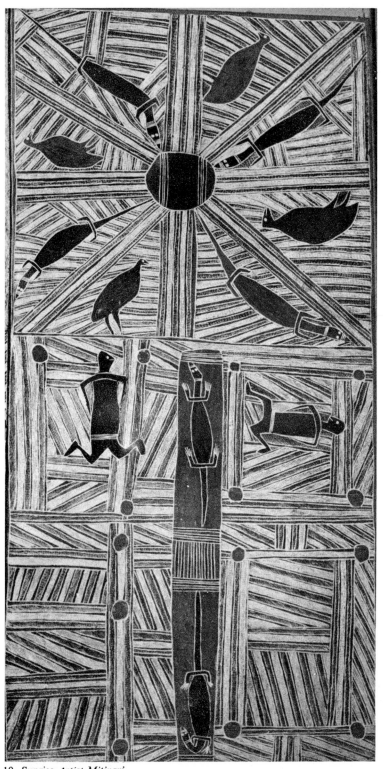

10. Sunrise *Artist Mitinari*

finds it difficult to travel far with dry feet. He has pictured the two sisters here on their own where they had camped after struggling through the trackless maze of mud, swamp palms, long grass, and gloomy paperbarks. The one on the left is already obviously pregnant. She had become very tired of moving through that difficult terrain. To add to their difficulties the two sisters had found it hard to discover where to dig for fresh water as most of the water in that country was brackish. When at last they found good water they made camp and rested there, and once they had rested they made a ceremonial dance to celebrate some of their travels and their adventures. In the picture they are dancing, but soon the older sister had to rest. They had been looking for a place to camp most of the night and found this good spot just as day was breaking, so Bitjiwurrurru was too weary to dance for long. She sat then, watching her sister and Djankawu continue the ceremony, after the two goannas had called out to them to see that the sun was rising. The two goannas, Djunda and another, had been watching for the sunrise, each one looking out of his own end of a great hollow log.

This log pattern, with its pattern of lines across the middle, is that belonging to Mawalan, handed down from father to son, generation by generation, tying him and his family into the Djankawu story and ceremonial. The people of this area still dance the ceremony of Djankawu and his sisters, greeting the sun's rising with gladness. The sunrise does not only mean light of day returning to the people of earth, it also means light on the hazardous journey from earth to the next world for a departing spirit, for the soul of one who has just died. For Djankawu and his sisters it meant light coming after a hard and difficult night, and a reminder that their friends on Baralku were still watching over them.

The big, dark python, Gunthurru or Wi'tig, is the marayin (totem) for this area, and this artist often paints the great snake in various forms, generally with some reference to seasonal activities, for this python is symbolic of the rainbow snake who calls up the monsoonal rains.

Creatures Greeting Sunrise

The top square of Mitinari's section is almost a pictured hymn of praise to the morning sun. The birds and animals, represented here by Djunda the big goanna, and Buwada the plains turkey, are all standing with faces

turned either towards the rising sun, or to the places where her light is dispersing the dark shadows of night with questing, illuminating rays.

The lines radiating from the sun are the rays of her light, spreading out over a newly wakened world. The shorter lines are trees, catching the first sunlight and marking long, thin shadows across the earth. The short lines that appear to be moving round parallel to the sunrise are thin cloud shadows, moving before the early morning breeze across the open plains. The fine lines drawn across the face of the sun are the tiny ephemeral cirrus clouds that sometimes lie close to the horizon, and, for a brief moment, draw a gossamer veil over the glory of the rising sun.

The Dua men say that they often call their wives by the inside name of the dawn sun, as a mark of deep affection and regard.

The story of the two ancestral sisters, who each possess several names in the legends told about them, and who are themselves held as the creative mothers of the Dua people of northeast Arnhem Land, is tied in with the more universally creative, life-giving figure of Walu, the sun. Both concepts led the Aboriginal's thoughts through the time of man's sojourn on earth, his obligations and privileges whilst there, and on to his hope of future immortality so long as he and his kept the laws laid down by the spiritual heroes of the "time before the morning". The ritual ceremonies of real value, held at intervals by these people, were re-enactments of the creative myths — to keep them alive in the minds of men, to identify afresh the living people with the spiritual ancestral figures, and by doing so to help control the environment and destinies of those people, and to remind all participants of the laws by which they must live to reach fulfilment.

Note

The end of the Dua myth, the story of a long journey undertaken for the peopling of the land and for the instruction of man by Djankawu and his two women, seems missing as it is painted on the panel. However, to a fully initiated man it is all there, for to him each meticulous line and symbol bears a known meaning. It is said that the spirit hero, Djankawu, returned eventually to his homeland of Baralku, leaving the two sisters behind on earth. There they were to keep watch over the continuity of the people, their welfare and their ritual behaviour.

In a separate bark (painted about the same time as that of the panels, by Mataman), the well-known legend of the sisters and Yurrlengor, the rainbow python, is shown in oblique symbolism but with an on-going connotation not often shown with that particular story. (The snake is said to have swallowed one of the sisters because he was offended by the smell of the afterbirth, when her first child was born near Yurrlengor's private waterhole. He soon regurgitated her, however, because her presence gave him stomach pains and the smoke, caught in her hair from the camp fire, made him cough.)

In Mataman's bark painting the two sisters are depicted as living still, in and beside a lagoon. They are said to continue occasionally giving birth to men and women who emerge from the lagoon as adults, stand on the banks in the sunshine to dry, and then move out into the world to mingle with the normal life of the local people. The two sisters spend their days hidden in the centre of the lagoon underwater, but in the night-time they come out to camp on the land.

This lagoon is buried in dense jungle and well protected by sharp-edged palm leaves and thorny vines, so impenetrable that only the initiated ones who know the four secret pathways to it can find the place. Adjacent to the lagoon, in a clearing amongst the jungle trees, the elders of the surrounding groups of the Dua moiety meet to hold a part of the Narra ceremony at intervals of time. This particular ceremony is a ritual of power and carefully guarded tradition, belonging only to those fully initiated to the inside circle of seniority.

Yiritja Panel

Legend of Banaitja

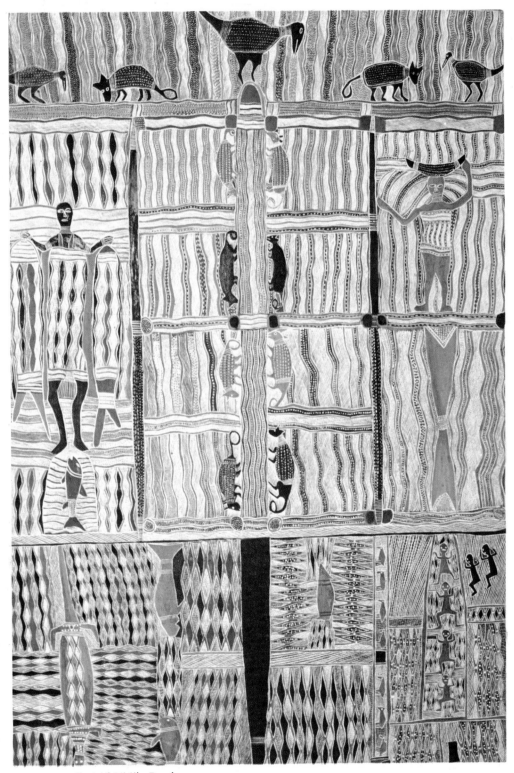

Part of Yiritja Panel

Yiritja Moiety

When their superintendent spoke to the artists of Yirrkala about placing something from their own hands in the new church, they were enthusiastic.

"What sort of a something?" they asked, wanting to know what would be acceptable. They were told that it should be something of their own choosing — preferably one or two large paintings, but that the subject matter would be left entirely to their own discretion.

So the Dua and the Yiritja people each painted their panels in the way that seemed to them best and the Yiritja arranged their offering in quite a different way from that of the other moiety. The Yiritja men worked in three close teams, each of the three language groups represented taking one third of the great panel under their leaders, Birrikidji, Mangarawui, and Naritjin. The legend of Banaitja and his companions runs like a strong thread through the completed panel, which rises in a design of harmony and balance from the bottom to the top. Within each section is also painted the ancestral lore belonging to the language groups, for the more personal legends rest in or are controlled by the overall mythology of Banaitja, with his companions, Barama, Laintjung, and Galparimun.

Soon after recording of the Yiritja legends began, Naritjin, acting as interpreter, turned to the older men and asked an abrupt question in their own tongue. Both Birrikidji and Mangarawui gave him deliberate answers to the slow accompaniment of emphatic nods, leaving no doubt about their desire for the telling of the full story. Naritjin sat quiet for a minute or so, a pleased smile flickering across his dark face as he appeared to be rearranging his thoughts ready for their presentation. At last he spoke. "This time I give you the yuwalk (true) dhawu (word)", he said.

Then, by an oblique twist to the story he was relating, and with the addition of new material, a quite exciting depth of meaning was given to what had been the routine outline of an already well-known legend.

Within both panels are painted dancing groups of men, representing various sections of the big ceremonies. When asked why their people held these ritual dances the answer was always the same in essence, "For remembering the law and the word of the ancient ones". In various ways it was explained that the virtue of the ceremonies lay in reminding the people, old and young, of the sacred word given by the ancestral heroes in the Beginning. This word was the law by which they were expected to live day by day, law governing not only their obligations to their kin and to their fellow men, but containing rules of behaviour towards the world

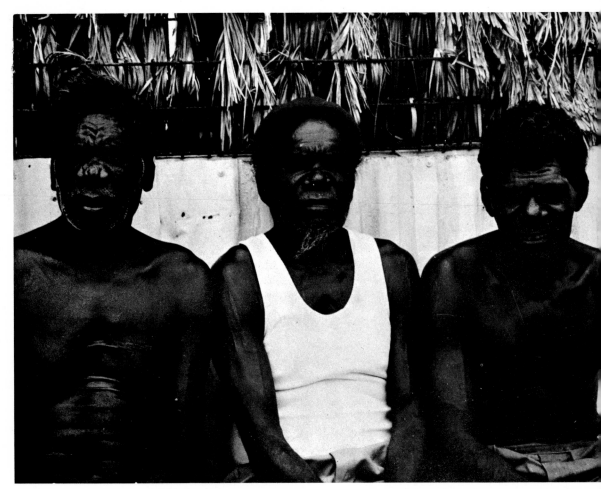

Three Yiritja Leaders

of nature, animate and inanimate, and finally, guidance through marayin or totemic symbols into contact with the living presence of spiritual power — including preparation by correct ritual for one's future life in the spirit realm.

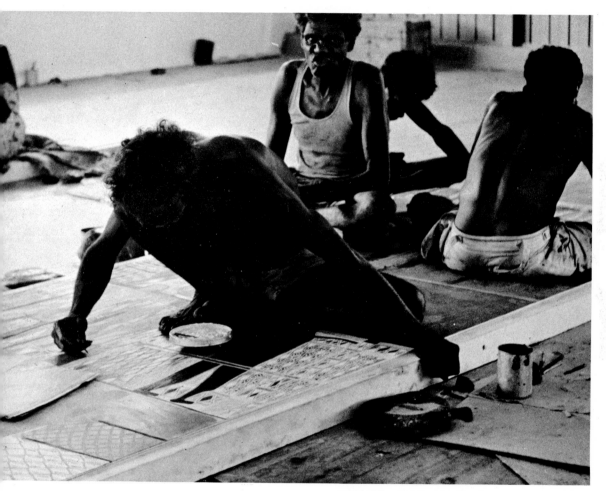

Yiritja Men Painting the Panel

Within the stories of both panels this concept of reciprocal contact with the spirit world is very strong. In the Yiritja panel the thread of mysticism is interwoven with courageous intelligence, though poetry and an appreciation of the truly beautiful is also there.

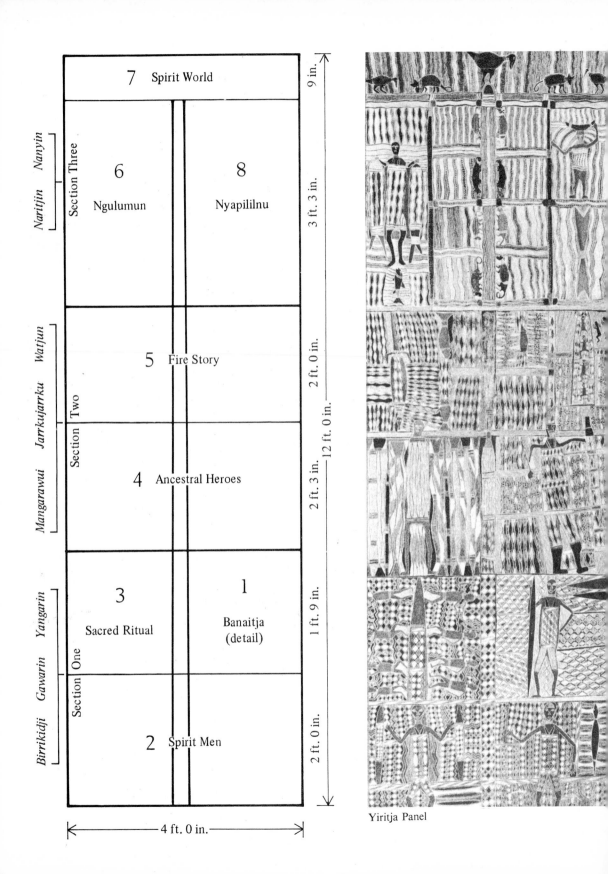

Yiritja Panel

The Country
of Banaitja

The Yiritja panel stands at the right of the Cross as one faces the screen. Artists of three language groups, under the leadership of Birrikidji, painted their story in three distinct sections, reading from the bottom section to the top one and taking the section of each group as a distinct part of the overall legend.

SECTION
ONE

Long, long ago, so long ago that men cannot number the wet and the dry seasons between that time and now, this earth was an empty place, neither fully land nor sea. The great ocean heaved and broke across the foundations of the world, covering all things and itself being covered with thick layers of foam and sand and sea-wrack that the waves beat up from below. At last, in places, the foam layer became thick and firm, to become finally the earth on which men can walk to this day, a land that hardened into the rocks and soil we know. There, in due time, grass and ferns and trees grew, and living things were able to sustain life thereon. And at length men found their way from one place to another, making the country of their choice to be their home and hunting ground.

Those early men were simple ones, living among the animals and birds as elder brothers, having spirits that could move from one to the other form as it seemed needful. At times either man or creature could in reality be a creative spirit, using the flesh of earth as a temporary medium.

In the days of the Beginning, four men arrived on the shores of northeast Arnhem Land, coming from some place of mystery beyond the eastern horizon, where the sea meets only the sky. They were spirit men taking human form, and had come to instruct early man in many needful things. They walked up out of the sea and went their ways, each doing the work he came to do. Two of the men, Banaitja and Laintjung, appeared to men as they emerged from the sea; but the two others moved inland unobserved, to show themselves first to men in the inland country of freshwater springs and swamps. These were Barama and Galparimun.

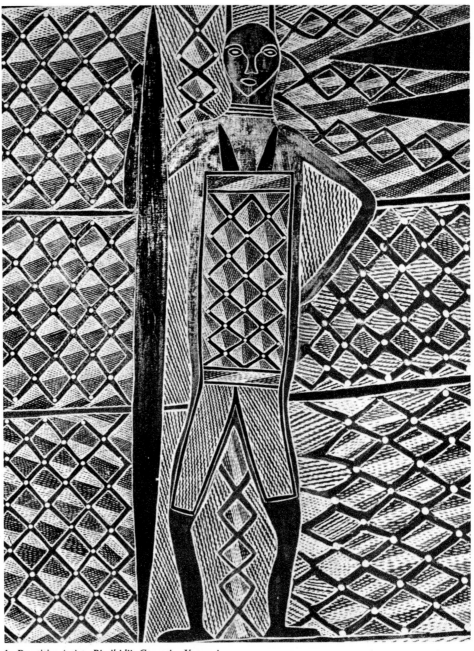

1. Banaitja *Artists Birrikidji, Gawarin, Yangarin*

Banaitja 1

On the panel, Banaitja is second from the bottom, on the right.

Banaitja was a very large man, strong and able and handsome. As he rose from the sea, walking up out of the water on to the beach, foam and spray ran in white lines down his body and dripped from his elbows. The foam formed a diamond-shaped grid pattern as it dried. The diamond pattern painted on Banaitja's body in the panel is that used to represent the honeycomb of the native bee, and that is the totemic symbol of Banaitja's people to this day.

In a painting by Yiritja artists a diamond pattern may mean several things:

the honeycomb pattern where the diamonds are almost square;

the fire symbol where the diamonds are slightly elongated;

running water when the diamonds merge one into the other in wavy lines; or the mortuary sign for a dead body if the short, crisp diamonds are arranged in a certain colour sequence.

Banaitja's Song

(A fragment of the ritual song of the hero)

> I am coming to the people of this place,
> walking strongly from the waters,
> rising through the foam and sea spray.
> I am coming to this country
> with the sea-foam marking lines,
> sacred patterns on my body,
> sea-foam dripping from my elbows
> as I move my arms in dancing,
> in the dhuyumirri (sacred) dancing
> of the dawn's creative Dreaming.

Banaitja came to the land with an air of calm authority, for he was from the spirit world and he was also very wise. And behind Banaitja came another man, his companion or his brother. This one was named Laintjung and he was nearly as tall as the first man. Foam also made the honeycomb pattern on his body as he rose out of the water and walked up the beach.

This other man, Laintjung, is not always clear in the songs and ceremonies that are held. Sometimes he might be only another name for

Banaitja, and he can sometimes be taken for another spirit man called Barama, for he often is an indistinct and shadowy figure, hovering in the background. When he is shown as an entity in his own right he is said to be brother of one man and father of the other, but these things belong to a time so long ago that no one now can be quite certain of what is the truth. Sometimes it is as if two men were walking one beyond the other, both moving as one body so that the eye can only see one man, except that the one man seems for a moment now and again to have a shadow beside him. This kind of shadow walking is one in which the yulnu excel when one man wishes to pass along an open space without being seen by watching eyes, so well can two hunters synchronize their movements.

But in the oldest ceremonial songs and on the correctly painted sacred barks, Banaitja and Laintjung and Barama are three whole men, each one a separate person, an individual spirit being, with each his own place in the ancient Dreaming.

For the painting on the panel in the church, Birrikidji has painted both Banaitja and Laintjung as one man, for that is the way they may be seen by those who are not initiated. Those who are of the inside word know and understand that the one is really two, and that is how it should be. The inside word, say the old men, is only for the wisest ones, whether their skin be dark or light.

Banaitja, moving about the country after his arrival, taught the people he found there many things. He gave them the language for each group of people and the area of land over which each totemic group might hunt. He taught them the special painting of the body for ceremonial occasions and for the burial ritual at time of death, and also the dancing for different occasions. It was Banaitja who gave men the word that is law and kinship behaviour. He also called up the wise man Guwark, the messenger, giving him power to use the form and wings of a bird to carry messages from earth men to the people in the spirit world and to bring back new word to men, the yulnu, after his body had been drowned at sea.

Banaitja is a very special name for the Yiritja people. He is said to be the ancestor for the Yiritja as Djankawu is for the Dua, for the senior men say that Banaitja and Djankawu are equal in all things. In the very beginning they were the same family, but in the songs and the ritual and the word they have grown apart over the centuries of earthly remembering.

The story of Banaitja is that he was so strong and wise and beloved of

men that the other three spirit men finally grew jealous of him and conspired to kill him. So together they speared him and his earth body died, while his spirit form became free to move about as it wished. He chose to remain in the country, rather than to return to the spirit world for all his time. The spirit of Banaitja is often near the sacred waterholes of legendary significance, or in the great paperbark swamps of the wet season. Sometimes his spirit is seen as the strange, watery light shining over the reeds and waterlilies of swamps, and sometimes it is the fine swirl of mist that hovers like smoke over the paperbark trees early in the morning. He is watching always over the yulnu, though one of his names is used by parents of small children to frighten them away from forest and jungle, so that they will not run far from their family camp and get lost in the bush.

Because of the fine, crisscross pattern that the foam marked on the body of Banaitja, the pattern so like the inside layers of paperbark, the inside of paperbark, tough, flexible, and very useful, is called by Banaitja's name. It is regarded as his skin, while the strong wood of paperbark trees is his flesh.

The most important and the most carefully guarded secret of Banaitja, told only in soft voices among the senior brethren, is that of the bones of Banaitja.

The story begins from the waterhole of Milingimbi, where the spirit form of Banaitja emerged as a barramundi fish, soon after his killing. From here he moved about the country of northeast Arnhem Land, distributing the bones of his earth body to the various groups of people, marking the areas of each group by the inside name of each bone; tying that piece of land to that particular totemic group of people for all time. The tribe of people belonging to the name of a bone belongs always to the special ceremonies associated with that name.

The painting symbol of Banaitja is the barramundi fish, and the symbolic mark that represents the barramundi's tail carries with it the power of Banaitja to those who paint it and to those who can read it.

The picture of Banaitja on the panel is of a tall man, his torso covered with the honeycomb pattern that is his mark. He is standing as he would at the beginning of a ceremony, holding in his hand the sacred marayin (totem). It is a hardwood stick, sharp at both ends, and its primary purpose is to prise off the sheets of paperbark from the parent tree. It is also used for digging honeycomb out of a hollow tree. This totem mark, drawn by

itself in a painting, tells the initiated men that Banaitja himself is represented in the painting.

The hatchings to the left side of Banaitja are differing symbols for honey and honeycomb. The two dark cones are the totem marks for honey and the bee, the marks used for the making of totemic objects representing the bee and also for a ground marking for ceremonies that include the bee totem in their ritual. Those chains of diamonds at the top are for honeycomb inside a hollow tree; the middle area shows honeycomb, full of honey and of young bees; the lowest part represents bees at work, moving about the honeycomb on their various duties — the storing of honey, the making of wax and moulding of honeycomb, the feeding of the bee babies and the making of bee bread from pollen. Other minute variations within the honeycomb pattern show flowering trees and plants from which the bees gather their nectar. The grids of hatching to the right of Banaitja, beside his totemic digging stick, are the pattern that is painted on his body.

2 Spirit Men

Galparimun

Below the picture of Banaitja, in the lower right hand corner of the panel, is the figure of another spirit man. This man, Galparimun, is said to be either a friend of Barama, the other figure on the bottom section of the panel, or son of Barama and father of Banaitja, in the ancient mythology.

Galparimun appeared with Barama in the spring waters of the inland hills and paperbark swamps, somewhere to the south of Milingimbi. From this inland range, called Burawunji, the freshwater streams flow from one side towards the Milingimbi country to the north, and from the other side to Blue Mud Bay in the southeast, running from lagoon to lagoon, and spreading into the mighty paperbark swamps in places.

In the picture Galparimun is holding a mungul, a spear-thrower, for he was a mighty hunter. Near his foot is the freshwater turtle that belongs to the special Dreaming of his country, which is also that of Birrikidji and his son, Gawarin.

Galparimun belongs, in the ancient mythology, to the swamp country.

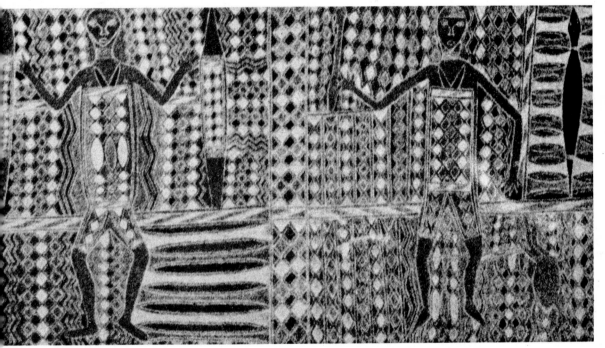

2. Spirit Men *Artists Birrikidji, Gawarin, Yangarin*

He taught the local hunters many things about hunting, especially hunting among the freshwater swamps and lagoons. He taught them how to plant trees and logs to make the water run in chosen channels, making it stay in the right streams for weirs and fish-traps. Trees can be seen in the background pattern of this man, forming a fish-trap above the head of the turtle. A big swamp python is caught in the fish-trap, together with numerous smaller snakes, freshwater fish and other creatures understood in the symbolic hatching. This particular python also belongs to Birrikidji's special dreaming.

The lower part of this criss-cross hatching represents running water, and the upper part, around Galparimun's head, is the honey bee pattern. During the creative period when this ancestral figure and his companions walked on the earth, Galparimun taught the people how to live in the

swamp country and also in the low, flat country where the fresh streams run into and mingle with the saltwater tides. There the movement of the sea on the rising tide makes eddies and circles on the surface of the waters where the salt and the fresh waters meet. These are near the bottom of the panel, near Galparimun's feet.

Barama

The man in the left section of the bottom panel is Barama. He is a more significant figure than his companion, Galparimun, as he is now the head spirit for the Yiritja people in the spirit island of Baralku. Also he taught the people the painting and the ceremonies belonging to the earliest times.

In the painting Barama holds the marayin, the sacred totems, here made of hardwood. These two totems represent the two main spirit men, and the marks near the top of the totems are the marks left by the water from which each man came. At the big ceremonies involving Barama these marayin are used by the senior men to represent the two companions as they emerged from the spring water near the area of Blue Mud Bay. The totems are made of very heavy wood that sinks in water and one of their most used names is "Bot". The other names may only be whispered among the men who have been initiated. The dancing ceremony for these spirit people is the Garngun ceremony, which is a part of the big Narra dancing. The performers who hold the totems in their hands as they dance this ritual are called at that time the Birrimamirri, because they are holding the totem of the spirits. The reason for dancing this ceremony, as with most other ceremonies, is to show the law and the customs belonging to the ancient mythology, so that the younger ones will learn the word and believe in it.

The painting on Barama's body is taken from the inside grain of the big swamp paperbark, because he belonged mostly to the country where they grow. It has something from the flowing streams in its pattern as well, making it a bit different from those of Banaitja and Galparimun.

The trailing lines from Barama's elbows and from his feet represent the seaweed, trailing behind him as he first came from the sea, before he went inland to reappear in the spring water. The hatching around Barama means several things — the honey pattern, running water, water moving the long reedy grass as it flows through the flooded swamp lands. The diamonds

below the fish-trap are freshwater pools where fish can be caught. The fish-trap is made of trees and logs and posts. Its opening can be shut at night so that in the morning it can be full of fish and water snakes. Several pythons are shown in symbol here in the pictured fish-trap.

One kind of fish-trap taught by the ancestral heroes was a barrier near the mouth of a small creek or tributary stream. The people walked through the creek towards this trap, causing the frightened fish to wriggle and jump over the barrier into bark baskets.

The story is that Barama and Laintjung gave some special word to Banaitja, through Galparimun, for Banaitja was able to talk to the local people with ease. This special word was the story belonging to each of the spirit men and Banaitja, the leader, was able to pass on the stories to the yulnu. These stories were given in the form of songs and ritual dancing, with the addition of totemic symbols to represent the different spirit men and their own totemic symbols of power. It was because Banaitja was able to communicate with people and to be loved by them in return that the other three spirit people finally grew jealous enough to kill him.

Banaitja is, however, still a legendary power in the land, for his death released him from the bondage of a human body, though he chose to remain as part of the mystery and life of the area.

Laintjung and Galparimun have retired somewhat into the shadowy reaches of the spirit world from whence they came, but Barama, even after his return to the unseen places, is said to have stayed in touch with the people of earth. His lines of communication reach through the mythical "tree of life", by the aid of animals, birds, and flying insects, the story of which belongs to the central column that runs up through the entire panel.

Sacred Ritual 3

In the section of the panel immediately above Barama, is the picture of a dancing ground with eight men holding a ceremony. The eight men represent the tribes belonging to the eight artists and their tribal affiliations.

The ground pattern is that of the honey totem and the dancing is a section of the great Narra ceremonial. The Narra is a long, all-embracing period of ceremonial and ritual dancing, and parts of it are performed separately for specific occasions and purposes, such as the release of the spirits of

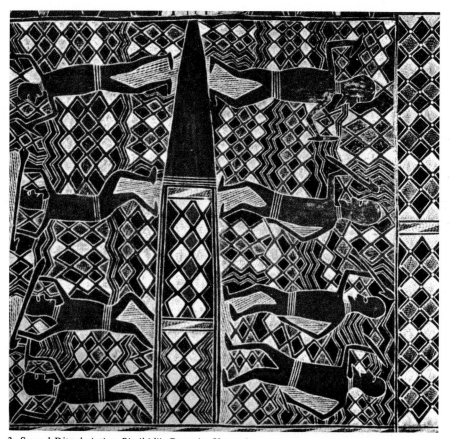

3. Sacred Ritual *Artists Birrikidji, Gawarin, Yangarin*

those recently deceased from the bondage of earth, mourning rites, circumcision, adult initiation ceremonies, participation in seasonal changes of the year, and renewal of the spiritual powers and physical well-being among the people. As a part of these ceremonial gatherings there are the clearing-up of old feuds and vengeance animosities, the arrangement of future marriage obligations, the exchange of ritual gifts, and the ingathering of news from outlying tribal lands.

The dencing of the bee totem is that of a large circle of people which includes several language groups and tribal areas of country around and adjoining Arnhem Bay. During part of the bee dance some of the symbolic

movements of bees are mimed, including the "Wuh wuh" sound in the singing, which indicates the folding of the bee's wings as she enters the hole to her nest.

The section of the Narra ceremony that has to do with the release of the spirits of those recently died, is that of the bathing of their friends and relatives in the sea. This dance into the sea waters washes away the clinging affections that hold the waiting spirits of the Yiritja people to this earth. Once the ceremony is over the spirits may wing their way happily to the future spirit island of Baralku.

After a dancing ceremony the performers are presented with special food, ritually prepared for this purpose. Natu, the nut of the cycad palm, is one of the popular foods for this purpose, as it can be prepared beforehand and kept for some days without deteriorating so long as the nuts have been properly treated. This includes a first rough pounding, placing the broken kernels in bags and allowing them to soak in a waterhole for two to three days, and thus leaching out a poison from within the nuts. After that they are pounded more finely, rolled into circular cakes, wrapped in paperbark and cooked in hot ashes.

The Tree 1-8

Up through the centre of the Yiritja panel, from the bottom to the top narrow section, is a column. This represents the sacred tree, the Tree of Life. The name of this tree is Waligul. It is a tall, strong tree — a species of paperbark by its description, for the bark peels off in the familiar layers and is useful for a great number of things. This bark is very durable, lasting a year or more in constant use. The tree, Waligul, grows on the dry ground but adjacent to the great inland swamps.

The mythical tree represented on the panel is said to be the communicating link between earth and heaven, with its roots in the earth and the normal living of earth, its trunk lifting through the songs and ceremonies and the art of the people, to its high branches which are hidden from sight in heavenly places and in touch with the spirit world. Only early in the morning, just before sunrise, may this tree of myth and legend be seen by the senior men after a night of ritual singing, and then it is only seen for a

brief, fleeting second between the passing of night and the coming of daylight.

Up and down this tree move possums and cicadas, taking messages from earth to heaven and returning with answers from the spirits above. Guwark, a small black bird with ruby coloured eyes, is one of the chief messengers on really spiritual or ritual matters, flying from the upper branches of the tree to the island of Baralku itself.

In each sectional part of the panel, the artists of that section have used the pattern of the tree to show some part of their own story. In that of the Duluangu men, the column is the mortuary post wherein they bury the bones of one found ritually worthy of being so honoured after death. The distinctive colour sequence of the honeycomb pattern is that of the burial place of a "dead one", and is used for that purpose in decorating bone posts for burial, or the hollow tubes of rolled and painted bark, used by relatives to carry specific bones of their deceased one during the period of mourning rites and ceremonies. Sometimes, too, bone relics carried in this way would be potent for stirring up the excitement of vengeance feuds in the old days of kin group entity.

SECTION TWO

4 Ancestral Heroes

These two figures, painted in the lower half of the Gumaitj section of the panel, belong to the particular Dreaming of the country belonging to the artists and are ancestral figures of the Gumaitj-speaking people, within the Banaitja mythology. One is the spirit of fire and the other the spirit in control of the source of painting materials, and their ritual significance and usage.

Wirrili

Wirrili is the tenuous figure on the left side of the panel, his tall figure blending in with the hatching pattern of his country, which is Buldjan, near to Caledon Bay. This spirit figure is the ancestral hero of the Gumaitj

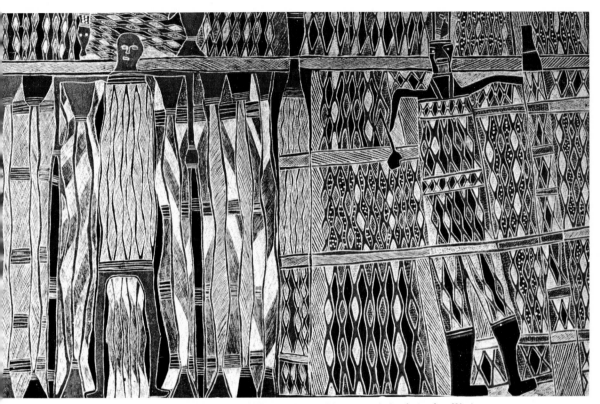

4. Ancestral Heroes *Artists Mangarawui, Jarrkujarrku, Watjun*

people, and his country embraces great areas of paperbark swamp country
between Caledon Bay and Melville Bay, and taking in the more hilly
land of Buldjan.

Wirrili's particular hill country of Buldjan is a dry, stony place, of
sudden small gullies and cliffs of coloured earth and stone, where quick
little springs run their water between yellow clay banks. This country is
precious, and in parts, sacred, for here the Yiritja people can obtain the
clays and soft stones used as the pigments for their painting on body, bark,
and cave wall.

This ancestor, Wirrili, taught the Gumaitj language to the people, having been given it from Banaitja and Barama. He also taught them how to use their painting materials and the preparation necessary for their correct application, together with the dancing ceremonies that accompany the painting pattern of the great myths of this area. The Yarma ceremony belongs to this part of the country, and is usually held when a particular small palm tree bears a succulent heart. This heart is a very popular food with emus, who become so engrossed in eating their favourite harvest that they are absurdly easy to capture by the practised hunter.

In the picture of Wirrili he is seen holding the hardwood digging sticks used for obtaining the clay and soft stones for the painting pigments — the yellow ochre and dark red stones from creek banks, and the black from inside the sacred caves of this area. The hatching round this figure is of fresh water, running in fine streams from the springs of Buldjan, and the strata of coloured clays and earth and rock along the gully walls. At the top and the bottom of the wavy lines are solid blocks of colour. These truncated cones represent the places where the different colours may be found.

Murrirri

This spirit is also the ancestor of the Gumaitj people, sharing the same area of country as Wirrili, but with more emphasis on the paperbark swamps and plains. He is the bringer of fire and is the spirit controlling it, having taught the early men how to make fire and the ways to use it.

The diamond patterns surrounding the figure of Murrirri are of fire in its different stages. Diamonds containing white dots on colour are the sparks of moving fire, travelling through grass and undergrowth. The black diamonds are burnt coals left behind after the fire has passed over the land, and red ones mean either dying embers or smouldering ashes. White diamonds can represent either cooling fire or lifting flames, according to their placement in the design.

It will be seen that the fire diamonds are more elongated in shape than are those of the honey bee totem, and run together in open lines as fire runs through the bush.

Murrirri is holding his totemic symbol in his left hand and a short spear-thrower or mungul in his right. The totem is the same outline as the

part of the tree that runs between Murrirri and Wirrili on the panel, and is the outline drawn on the ground for the dancing ceremonials of the Gumaitj-speaking people. The outline of the totem is a symbol for the ancestral figures who emerged from the sea, and the mark, encircling the base or neck of the thinner part, is that of the foam round the neck of the emerging spirit man. The outline, when used for the ceremonial ground (Muralku), is dug out in a shallow trench (for part of the great Narra ritual), and is filled in afterwards.

A small bark painted by Mangarawui about the same period of time as that of the panel, when the stories were freshly alive in his thoughts, shows the country guarded by Murrirri and Wirrili in more detail. The area, running from inland swamp plains and small ranges to the coastal plains and mangroves by the sea, shows some of the creatures found there. By the edge of the sea proper are mangrove fish, nuika, and king fish; further inland where the saltwater inlets run towards the freshwater creeks are swamp mullet, freshwater crocodiles and catfish. The spiderweb is there, a special symbol of the fire country because of the indestructibility of spiders — the spiderweb is always newly hung from tree to tree in the early morning following a bushfire. From the spiderweb comes the idea for ceremonial use of string, and the pattern of a web, made into a totemic symbol by winding feathered string round and between two crossed sticks, means several things. One of these is the mist over swampy country early in the morning, and can be the spirit of Banaitja. Also on this painting the land birds and animals are represented by the crane.

Fire Story 5

The section of panel immediately above the head of Murrirri consists of various aspects of Mangarawui's fire story. Fire, Gurda, came down from the heavens as a shooting star from Baralku that landed alight on the earth. Fire can still come this way, the old men say, and if anyone finds the place where it fell, picks up the ashes and smells them, he or she will soon die — for the shooting star came directly from the spirit world and calls that person's spirit home to Baralku. The only way the finder can combat this is by doing a ritual work of making something special out of paperbark, either of bark or of wood, thus diverting the spirit of the man from the call of Baralku that the ashes still contain.

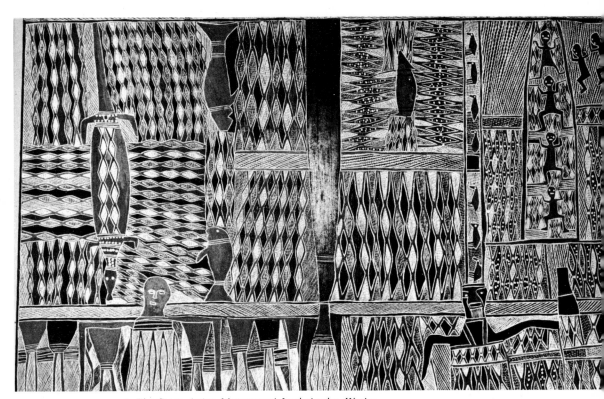

5. Fire Story *Artists Mangarawui Jarrkujarrku, Watjun*

Whether the fire spirit, Murrirri, organized the coming to earth of fire by means of the shooting star, so that it might be useful to man, or whether he was the first man to find the fire after it had arrived and realized its future potential, is not clearly defined in the story. His particular friends among the bush creatures are those animals and birds and other living things which were able to survive fire after it had swept across the country. The little bush quails that run so fast through grass and undergrowth were able to warn the other bush dwellers of the coming of fire. The bandicoot had sense enough to burrow under roots or into rock clefts for safety. The spider, by some miracle only known to arachnids, was able to find refuge under shreds of bark while the flames leapt through the standing trees. Another little bird, Jikai, the honeyeater, builds its nest up high in

the trees, out of danger on the long green branches. It sings for joy very early in the morning, to tell the world that the fire has passed it by. The ceremony being danced on this part of the panel is that of this little bird.

The narrow column immediately above the head of the fire spirit, Murrirri, shows the quails running through the grass away from the fire.

At the right of the quails the lower two-thirds of the area are still on fire, with sparks flying as newly caught material bursts into flame or a burnt limb falls in a shower of sparks from its parent tree. Above that part are unusual white lines, and these show ground that has been left bare after the passing of a bushfire, with white ashes lying in streaks over the earth, as it cools.

The two women, Juwandaingu and Gurrirri-gurrirri, are crying bitterly because the fire has swept over their earth and they cannot find the yams and other bush tucker for which they are hunting. They are the wives of two of the dancing men and are there to look after their husbands by collecting and cooking food for the dancers.

The four men on the ceremonial ground were able to hold their dancing as the ground had been prepared and was already bare when the fire passed by. They are Murrirri, the headman, Bulanadji, Muniwayangura, and Munapaynmirri, and are dancing the ritual of the fire dreaming, concentrating especially on the songs of the little honey eater, Jikai. In this particular section of the dance they are showing by the stylized movements of arms and feet how the little birds leave their nests at night to sleep further out on the swinging tree branches.

At the left of the quails is an area of bush where fire is moving in swift flames, through thick undergrowth and trees and long grass, before a strong wind. At its upper and lower borders are burnt out strips left from the passing of the fire. Above that is a bandicoot, hiding in a hollow in a clear patch of ground where it has been wise enough to seek safety. Above and below the bandicoot, Galaidbal, is fire running through small twigs and dead leaves around his stony little refuge, while to either side of him the moving sparks of the bushfire leap and crackle as the fire travels through the denser growth, further away.

This half of Mangarawui's section of the panel takes his fire story right across from side to side. (The part of the tree here, through the centre of the section, is the bare shape of the ritual ground and of the unpainted totem, which is decorated with ritual painting in the lower half.)

The left half of the fire story shows where the fire ran through the great swamp flats, burning the swathes of reeds and cane grass that have been left after the swamp waters have receded and dried out during the dry heat of the hot, rainless months. Here the dugong, above, and the rock cod, below, are lying in the cool safety of the saltwater creeks, while the bushfire rages on the banks nearby. Wuimeri, the dugong, is feeding on seaweed, seen as the misty hatching near the creature's head and tail, whilst Dhalarawui, the rock cod, is resting under a shelving bank. Both are good eating.

Barru, or Dinbal, the crocodile, is part of the great fire myth.

Once, in the long ago, Dinbal was a land creature, living on the grassy coastal flats that are bordered by mangroves and salty inlets. It was Dinbal, the crocodile, who discovered how to make fire on earth by rubbing dry sticks one against the other. But he did not know how to control the flames when they escaped from him and went rushing furiously through the grass and undergrowth of the bush, burning all before them. One of his forearms became badly singed by the leaping fire, and in fright he took to the nearest creek, a saltwater inlet. There he settled, finding the water to his liking, while the muddy banks were ideal for basking in the sunshine and for his mate's egg-laying.

Another denizen of the saltwater creeks was the giant stingray. He objected to the coming of the crocodile into his territory and challenged the newcomer to a duel. A mighty battle followed as the waters were churned to froth around the two immense creatures, who were evenly matched as to strength and agility. However, the stingray had one weapon that was more potent than even the cruelly sharp teeth or the battering tail of his opponent, and that was the sting in his whiplike tail.

At length the stingray was able to manoeuvre himself into a position where he could use his sting, and he struck its terrible barbs into the crocodile's hind leg. The pain was so great that Barru gave in, holding up his wounded leg as a token of surrender. From that time there has been peace between the crocodile and the stingray.

The peculiar raised stance of the crocodile's injured leg is used by the main contender in a makharata — a peace-making ceremony — at the close of his ordeal by spears. Lifting his knee and offering his thigh to his chief opponent, he signifies submission to the tribal sense of justice and vengeance. His thigh is then stabbed with his rival's spear in a ritual that

must end in the flowing of blood for the sake of peace. The two contenders often then walk away together in open friendship, as the crocodile and stingray did in the early Dreaming.

(A makharata is the ceremonial termination of a long-standing vengeance feud, begun by the killing of one man by another and carried on by the close relations of the "dead one", sometimes through several generations. The makharata finally closes the matter between the relatives of the two opposing factions, usually before a large ceremonial dancing takes place. The defender, either the killer himself, his descendant or a close kinsman, stands in a ritual bombardment of spears thrown by members of the offended tribe. Most of the spears are blunt, with sharp blades either covered in tightly bound paperbark or with spear heads removed, but the final one is usually aimed with deadly intent and complete with spear blade. The man on the receiving end is armed with only his spear-thrower, and with this he parries the flying spears. This is a game still played by the young boys, with grass canes for weapons, and it is here they become expert at eluding the flying spears — a very useful art in their ancient, nomadic world.)

<div align="right">

SECTION
THREE

</div>

Naritjin has woven his own people's legends and sacred Dreaming intimately into the overall pattern of the Banaitja story, as Birrikidji and Mangarawui have done. His legend, however, is subordinate to the great Yiritja myth of the creative heroes, and finishes at the top with the spirit world of Baralku.

<div align="right">

Ngulumun 6

</div>

To the left of the central column in this section is a tall man, seen standing above a swimming fish. His name is Ngulumun and he is the ancestral hero of the Manggalali language group of people. He was given his place as the head man in his locality by Banaitja.

Ngulumun was a large and powerful man and a mighty hunter. He is

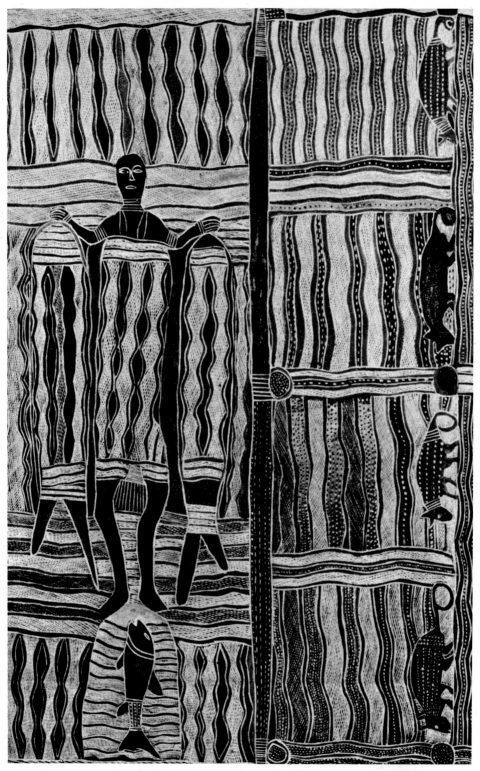

6. Ngulumun *Artists Naritjin, Nanyin*

now the guardian spirit of the land belonging to the Manggalili people, and of their kinship totem, the king fish. In either hand of this spirit man are the hardwood totems of the king fish, decorated and painted ready for a ceremonial dancing. These totem figures, being carved in a very hard wood, are durable, so when the particular ceremony is over they are hidden in the banks of a stream until required again. Then they are taken out, cleaned and repainted by the men entitled to do this task, while the other senior brethren sing the songs appropriate to the totemic story belonging to the fish.

The local people say that this particular fish grows up in fresh water, coming down to the salt water when fully grown. When they come to the coastal area again in quantity, the female fish is usually full of eggs. The place belonging especially to Ngulumun within his area of country is a region of freshwater creeks where heavy woods grow. The fish in the picture is seen swimming in a deep pool of fresh water between rocky banks. The hatching round Ngulumun and the fish pool is of the surrounding country of dry hills and little, steep gullies whose waters run into the larger streams.

The wife of Ngulumun is guardian of water root foods, especially of a large waterlily root that is found deep down in the streams of that country. She is not shown in the panel, but her hardwood digging stick, often used by Ngulumun for obtaining sheets of paperbark from the big trees, is the narrow pointed pole that runs from top to bottom of the picture, beside Ngulumun's left hand.

This man, in the pattern of other ancestral heroes of these people, taught the yulnu of his language group their language, their painting symbols, the ways of hunting the local animals, birds, and fish, and, most important, the ritual songs, ceremonial dancing, and totemic symbols belonging to that group of people. This knowledge was given to him by the wise ones of ancient times, Banaitja and Barama.

Spirit World 7

The central column of the panel here reveals its true character as the tree connecting the sacred and profane, the heaven and the earth, a link between the spirit people of Baralku and the spirit lands, and the yulnu, the people of earth.

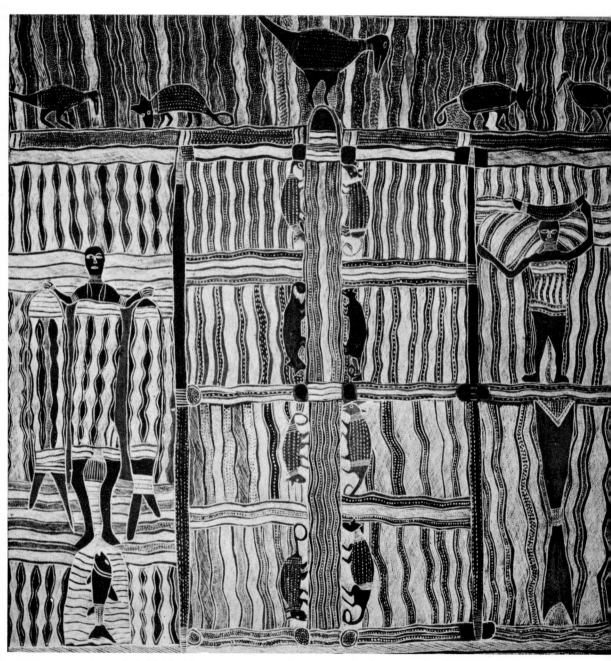

7. Spirit World *Artists Naritjin, Nanyin*

The possums running up and down the tree of life are messengers, bringing word from Barama to men and taking messages back from men to the spirit world and to Barama. Barama is the spirit hero who has most to do with living men.

At the very top of the tree stands Guwark, the black bird who flies between the tree and the spirit world, crying from the tops of the tallest trees his messages to men, when they are new or urgent.

The living bird, Guwark, is a bird about the size of a butcherbird, with iridescent black feathers and ruby red eyes. One of these birds, shown to the author, sat quietly in cupped hands until released, as if quite unafraid of human contact. The people say Guwark cries loudly from the tree tops early in the morning or late in the evening, and right on into the night if he has a message to deliver or it is bright moonlight. His cry, "Guwark, guwark", is clear and strong. His wife is much less obvious, crying "Pe-et, pe-et" in a softer and more plaintive voice. She stands at the end of the top line of panel.

Guwark was once a very strong man called Yikawunu who lived in that "time before the morning" often called the Dreamtime. Once Yikawunu was travelling in a bark canoe with another man, out in the open sea. The people at the home camp on shore had warned the men that the canoe was old and could easily crack, but Yikawunu had said it would be all right. However, they ran into bad weather, with strong wind and rough seas. The string rope that held the inside struts together and held fast the sheet of bark, frayed and broke under the wild movement of the waves, and the canoe sank. Yikawunu, being the leader and very brave, gave the paddle to his companion so that he would not sink. That one finally reached the shore safely; but Yikawunu, in spite of being a mighty swimmer, was overcome by the shattering waves and was drowned.

The spirit of Yikawunu turned into the bird, Guwark, clothed in feathers and with strong wings. He flew to land and from there went on into the heavens. Now he can be seen in the night sky, camping along the Milky Way. His friend and canoeing companion, Murkayani, joined him there later when his time on earth had come to an end. Ever since that time Guwark has been the messenger between Barama in the spirit world and men on earth, using the possums and cicadas as helpers in contacting the people when necessary.

The lines behind Guwark and Peet and two of the possums at the top of

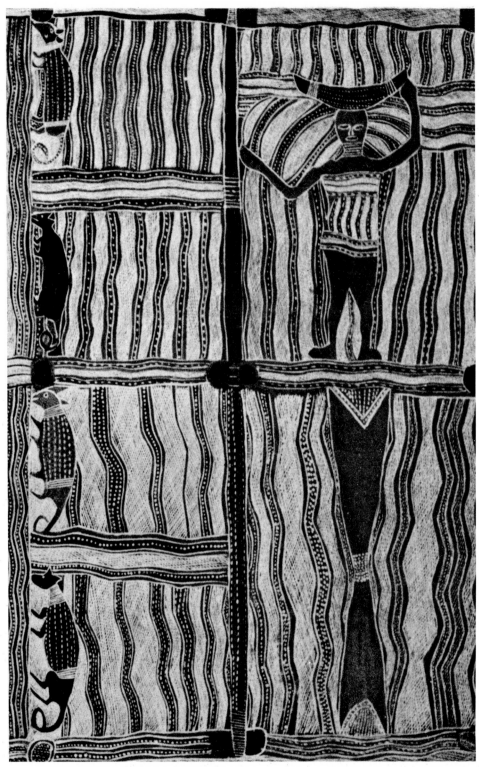

8. Nyapililnu *Artists Naritjin, Nanyin*

the panel are clouds and cloud shadows, with falling rain in places veiling the sky, and the spirit lands beyond.

 To either side of the possums, running up and down the central column, and within the borders made by the two digging sticks, are small panels of wavy lines. These represent various aspects of the country belonging to the artists and their tribal relations. Some are waves blowing before a strong wind, and those with dots in the sea sections are storm waves dotted with falling rain. Others are sandhills, with cloud shadows blowing across the country and an occasional shower moving with the clouds as they pass, and with the tracks of sand crabs and turtles marking the coastal dunes. The circular holes also vary in meaning. The black-centred circles are crab holes, while the lighter ones represent camps, some of men and some of birds; the lower ones are those of people and the top ones belong to either birds or to spirit men.

Nyapililnu 8

 To the right side of the panel, beyond the second digging stick, stands the figure of a woman carrying a bark food-container balanced on her head. This is Nyapililnu, in some ways a mysterious personality, for the legends about her are conflicting. Some of the more obscure legends about her place her in a position of equality to the Djankawu sisters, as ancestral mother figure to the people of the Yiritja moiety, taking the place in the Yiritja stories that the two Djankawu women take in the Dua mythology. Nyapililnu's legend, however, is not revealed by her followers as readily as is that of the Djankawu family.

 The nucleus of the Nyapililnu legend does not change, and it is painted in various aspects by Naritjin and his brother Nanyin in detail.

 Two men and two women came to the mainland in a canoe in the long ago. They were spirit people really, who had settled on Groote Island for some time but who finally moved over to the mainland coast. The two women, travelling with their husbands, were named Nyapililnu and Wurdilapu. They began hunting for bush food as soon as they landed, walking inland and noticing all the new birds and animals that they met on their way. When they were well back in the forest it began to rain, so heavily that soon the little fast creeks were racing seawards full of water

and whirling debris. Nyapililnu quickly prised off some sheets of paperbark as the rain began, for they had found shelter under a great paperbark tree. The sheets of pliable bark draped over the heads of the two women, keeping them dry and shedding the rain as they moved about the drenched land. From that time Nyapililnu became the guardian spirit for paperbark, finding out new ways to use it and teaching those ways to any women and children she found. The hardwood digging stick with which Nyapililnu tore off the sheets of bark from their trees, is named Wadjura, and is the digging stick on her side of the centre line of the panel. Uses of paperbark are many, for baskets in which to carry food or water or honey, the pliant sheets for making a weatherproof hut and for sheets on which to sleep in more comfort, either on the ground or on the sapling platforms of the mosquito-smoke houses; paperbark is also useful for wrapping precious things in, for a springy cushion on which to carry a newborn babe, and for wrapping nut and cereal cakes in for cooking. Nyapililnu taught the women how to make string of other barks, yirrawur, for use in sewing and tying paperbark baskets, and for making the women's cross-over breast ornament which they wear for ceremonial dances. The latter they often decorate with tiny, coloured parrot feathers.

In the picture Nyapililnu is standing with her paperbark cloak swirling about and behind her. The dots in the dark lines are falling raindrops.

Learning from Nyapililnu, men have adapted paperbark to their own use, especially in the making of exquisite ritual totems where they mould the outline in rolled bark and cover it so firmly and smoothly with string binding that patterns may be painted thereon in fine detail. To the Yiritja men paperbark is of very deep significance also as symbol of the skin of Banaitja, making it especially sacred.

Nyapililnu is regarded as the guardian spirit of women and children as they hunt in the bush. She is said to teach them how to find and harvest the various bush foods of tubers, fruits, nuts, and grass seeds, together with the ways to prepare and cook cycad nuts, and the waterlily seeds, wak-wak.

Below the feet of Nyapililnu are some strange shapes that represent rain clouds with curling edges. These edges are symbolic of the soft, feathered string of which many sacred or marayin things are made by the men. Also, here, they especially symbolize the string that outlines women's breasts on ceremonial occasions. The shape of the women's string is there, tied

in the middle with a feathered decoration and dividing to cross over the shoulders and around the breasts. This string is often made of possum fur, making a silken string of silvery grey.

To either side of the string-bordered cloud are passing clouds and rain showers. The rain water is running down into the flowing creeks that are shown across the bottom of this section, running past camps of men and on into the sea, over holes of the giant blue mud crabs. On the open beaches near to where the creeks meet the salt tides, turtles lay their eggs in sandy holes, a cache of good food for the passing hunter.

FINALE

To a man initiated into the mythology of his people, these pictures hold a depth and dimension of meaning: the companionship and fervour and poetry of the great ceremonials; obligations of the kinship system; the lore of the hunter and his intimate knowledge of the natural world in which he lives; all come to life in pictures that are rich with a wealth of mystical imagery. Stories of ancient heroes, passed on by word of mouth from generation to generation, have mellowed and slowly changed with time to a rich tapestry of mythology, called by some their Dreamtime.

The concept of the Dreaming or Dreamtime in reference to the Australian Aboriginal can be misleading, however. The creative legends and their meaning for the people are part of it, as is the far-off early time of man's beginning as a conscious human being, lost in the mists of uncounted centuries. The explanations sought by the spirit of man in regard to his existence on earth, the transiency of the individual life and his belief in an ongoing and immortal spirit, are also part of it. Those are the legends and meanings remembered in art and ritual and song — in small gatherings round the camp fire at night or in the great ceremonial occasions, remembered and passed on from generation to generation by word of mouth and vivid illustration of totemic art or miming dance at the initiation rituals, and treasured by those entrusted with its sacred songs and secret mystery.

But the concept of a man's personal "dreaming" is another thing. It is the dream his father has when his mother first feels the stirring of new life in her womb, a conscious and yet symbolic dream of a tract of country within the area of the land belonging to his language group, an area of land that gives the child its name as his ceremonial, hidden title, tying him for ever into his own rightful place within the ceremonial life of his totemic and kinship grouping.

NOTE ON ABORIGINAL WORDS

Aboriginal words when used in the text of this book are beside the English word that corresponds in meaning.

Pronunciation of aboriginal words is simple as they were written in phonetic spelling, to be pronounced as written without emphasis on any special syllable.

Where two r's are used a rolled r is indicated.

GLOSSARY OF TERMS

Aboriginal words used are from the Gopopuingu and allied languages of northeast Arnhem Land.

Armbands made of bark string, possum fur string or woven pandanus or twined grass, these are often trimmed with brightly coloured feathers and are worn mainly for ceremonial occasions.

Clap-sticks (bilma) a pair of hardwood sticks of varying shape — may be cigar, boomerang, or flat-sided pieces of timber, hand carved and smoothly finished. They are used to tap the rhythm for songs and dances.

Digging-sticks (mawalan) slender sticks of hardwood with both pointed ends fire-hardened — these may be up to four feet in length. They are used mainly by the women for digging root foods from the ground or honeycomb from tree cavities.

Drone-pipe yiraki) commonly known as a didgeridoo throughout Australia; a hollow wooden or bamboo tube approximately four to six feet in length, used to give rhythm and volume to the singing. A good player can make it throb on one bubbling note, a deep tone with an occasional falsetto note to add emphasis.

Hatching fine lines and dots that often fill the background of an aboriginal bark or body painting. Each distinctive type of hatching used places it within a particular school, thus identifying the artist's country and totemic affiliations.

Linguistic grouping people occupying one or more defined areas of land and who are a kinship group within one or the other moiety have their own dialect — sometimes only a variation in word endings, sometimes a different language.

Rakai (identified by Dr. Donald Thompson in 1935 as "Heleocharis spacelata"), the nutritious and prolific groundnut of a local lily, growing mainly in freshwater swamps adjacent to saltwater flats. Taste somewhat like peanuts and are harvested in great quantities in season. Also eaten by pied geese.

Ritual ceremonies as distinct from the casual camp singing and miming, these were disciplined affairs involving formal preparation, together with a detailed knowledge of the song-cycles and symbolic dance movements to be used during the ceremony. They were used as a time of initiation, for mourning rites, to celebrate the changing of the seasons, and to refresh the people's knowledge of the laws and sacred mythology that bound and upheld them in their everyday living. These ceremonies could be small and intimate rituals performed by the senior men of a kinship or totemic grouping, or large gatherings called together by formal invitation from the inhabitants of one territory to those of neighbouring kinship groups.

Sacred totemic designs a totem is primarily a symbol of either the central figure or personality of a myth — may be an ancestral hero, an animal, a product or a particular rock, tree or spring — that holds special significance for a group of people, usually during the ritual performance of the story of that myth. When the totemic design is painted on body, bark, or cave wall, it is often so simplified as to appear only a line or a cluster of lines that are understood only by the senior men of that totemic grouping.

Song cycles these describe, song by short song, the doings, adventures, and words of the mythological ancestral heroes, the ways of local animal life, the pattern of the weather — rain, storm, cloud, wind, drought, day and night — and of their country. They may be sung in unison, or turn about by several people each taking the part of one character in the myth. The song cycles may consist of anything up to a hundred and eighty stanzas or more, taking hours of singing and great feats of memory to perform accurately. To some ears the music sounds monotonous, but in reality it runs through many changes.

Spear-thrower (mungul) a piece of flat hardwood about as long as a man's arm, with a "crochet hook" point firmly tied on at one end and a carved handhold at the other. The hooked point fits against a shallow depression in the end of the spear haft, part of which rests along the length of the thrower, both fitting into the palm of the hunter's right hand. Considerable leverage is given to the flight of the spear by this method of throwing. Width of the body of the spearthrower varies with the country of its maker.

Trading item a ceremonial object — such as stingray spear or feathered string — used for the discharge of ceremonial gift obligations between men sharing cross-totemic values of exchange and ritual.

Yulnu (the people) local term referring to people indigenous to their country of residence.